DRAW

A GRAPHIC GUIDE TO LIFE DRAWING

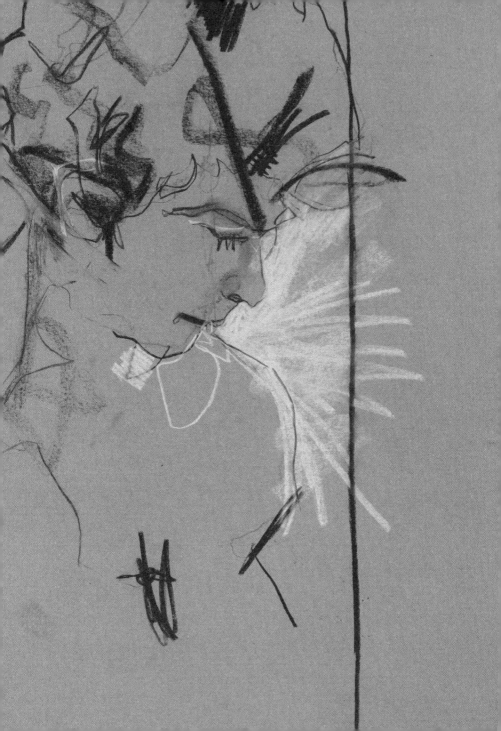

DRAW

A GRAPHIC GUIDE TO LIFE DRAWING

AMMONITE
PRESS

David Hedderman

First published 2017 by
Ammonite Press
an imprint of Guild of Master Craftsman Publications Ltd
Castle Place, 166 High Street, Lewes, East Sussex, BN7 1XU,
United Kingdom

ISBN 978 1 78145 280 6

Publisher: Jason Hook
Design & Graphics: Robin Shields
Editor: Jamie Pumfrey
Consultant: Louise Gorst

Colour reproduction by GMC Reprographics
Printed and bound in China

CONTENTS

Introduction 6

PLAN 10
Finding a Class 12
Basic Materials 14
Paper 16
Willow Charcoal 18
Compressed Charcoal 20
Erasers 22
Graphite and Pencils 24
White Chalk 26
Drawing With Colour 28
Other Items 30
Drawing Supports 32
Other Factors 34
Life Drawing 36
Portraits 40

MAKE 42
Line and Tone 44
Line 46
Tone 48
Drawing With Layers 50
Drawing the Head 52
Elements of Design 54
Focal Points 58

PLAY 60
Five Poses: One Minute Each 62
Continuous Line Drawing 64
Contour Line Drawing 66

Tonal Drawing 68
Non-Dominant Hand Drawing 70
Blind Drawing 72
Blind Double Portraits 74
White Chalk on Dark Paper 76
Four-Step Combined Drawing 78

GROW 80
Drawing Movement 82
Standing-to-Lying Pose 84
Working on Location 86
Experimenting 88
Developing Your Own Style 92
Aftercare 94
Framing 96
Working in Series 98
Portrait Project 100
Portrait of a Relationship 102
Self-Portraits 104
Landscape Drawing 106
Urban Environment 108
Turning a Hobby Into a Business 110
Setting up a Life Drawing Class 112
Plan for a Class 116
The Naked Model 118
Mindfulness in Drawing 120
The Students' View 122

Resources 124
Index 126
Acknowledgments 128

INTRODUCTION

Creativity is a word that not all of us connect with, but it is inside of everyone and in everything we do in our daily lives. It is in the way we spread butter on toast and how we choose to paint our nails. Drawing is a great way of awakening this creativity and, with practice, it can come to everybody in much the same way as learning a musical instrument or a foreign language.

Drawing is a discipline that people want to succeed at, but this will not happen overnight. To begin with, it may help if you view the process as a game. Keep yourself excited and you will find you can keep pushing in order to break through. Experiment freely with your drawing and see where it leads you. Remember, just like learning an instrument or language, the more you do it, the more 'natural' it will feel.

Once you get through this initial development phase you will find there is always more to discover. This was certainly the case with Alberto Giacometti (1901–66). When asked why he made drawings and sculpture, Giacometti answered that it was because it was the thing in life that he understood the least. He was devoted to mastering it and knew it was something that would keep him excited and busy for his whole life.

This book has been designed to strip away some of the mystery of drawing. Instead of overwhelming you with technical explanations, the aim is to inspire and encourage you to develop your own skills. If you focus on your own exploration and development, the rest will follow.

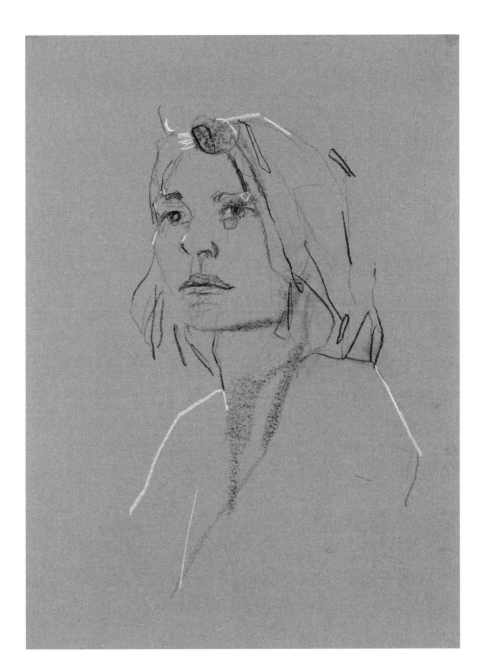

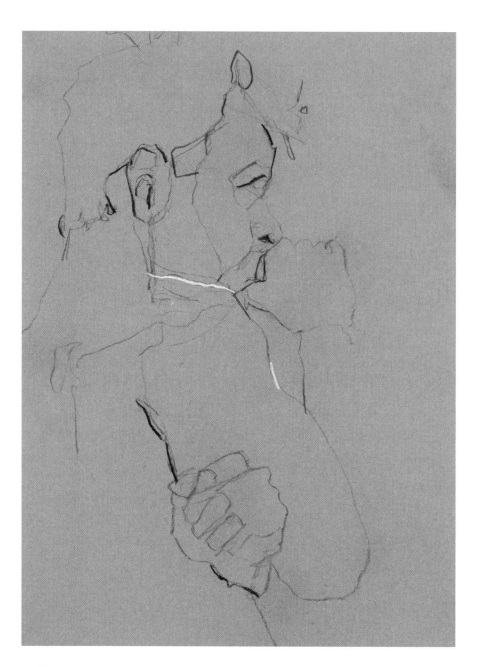

For the aspiring creative, life drawing classes can be an important part of the learning process. If you want to get good at drawing, learning to draw from the figure and the world around you will open the window of possibility. Of course, you could ask a friend to sit and model for you, but the wonderful thing about joining a class is that it provides you with a routine for your practice. A class will also enable you to familiarize yourself with the medium, learn from your peers and watch your skills develop over time.

Most of the images used in this book come directly from life drawing classes and help to illustrate what can be achieved. Poses range from one minute to 30 minutes, but they have all been drawn with the same media – charcoal, paper, putty and sometimes a little chalk, pastels or watercolours to bring in some colour.

When you are first starting out you will find the idea of creating 'good' drawings restricts your ability to relax. It helps enormously if you can take the pressure off and enjoy your drawing. When you do this, you'll begin to notice your progression and the 'good' drawings will come (and when they do it is a great feeling!). At the same time, avoid throwing out any 'bad' drawings. You may not view them as being successful, but try to think of them as research: those drawings are your teachers and they won't lie to you.

As you develop your drawing abilities, you will also find that the process has the potential to open up many other interesting projects and can become a beautiful way to document your life.

PLAN

Developing observation skills and being able to express what you see on paper will take time. Do not let this frustrate you, though. You may not think it now, but creativity is in everybody and it is mostly the thoughts in your head that will prevent you from unlocking it. Think like a young child: they never judge their creations, seeing them as good or bad, they are just happy in those moments of making them. Be like that child. Enjoy the process!

The most important thing when you are learning to draw is to keep the practice alive in your weekly routine – you must keep the drawing 'muscle' active in order to develop it. Practically speaking, this is about turning up every week to your drawing class with everything organized for the start of the session. You should also take the time to catalogue your drawings, assessing them to see what draws you in. Critiquing your own work in this way will help you make decisions about where you want to take your drawing journey.

FINDING A CLASS

The first step on your drawing journey is to find a life drawing class in your area. Although there are often lots of these around, there are several things to consider. Ultimately, though, you need to make sure you are comfortable with the class – if it doesn't feels right, find another one.

ABILITY LEVEL
Life drawing classes are aimed at different ability levels, so choose one that best reflects the level you're at.

CLASS SIZE
The larger the class, the less time the tutor will have for each student. This isn't necessarily a bad thing – it's up to you whether you want hands-on tutoring or prefer be left to develop on your own.

ATMOSPHERE
A calm and relaxed atmosphere will allow you to concentrate entirely on the model and your drawing without distraction.

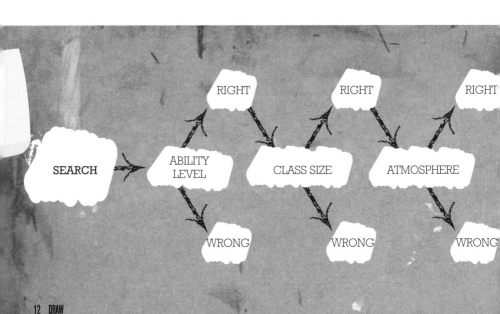

MODELS

Find a class that uses a wide range of models, with a variation of age, gender, size and look. It will help to improve your understanding of the body, and it challenges you to think about your composition when things aren't the same every week.

LIGHTING

How your model is lit will greatly affect your work. A variety of lighting will allow for a better understanding of shape, tone and shadow.

INSTRUCTOR

The intimate nature of a life drawing class relies on it being run in a professional and sensitive way. The instructor's main job is to facilitate the class, which means looking after the model, organizing the poses and keeping a check on timings so that students can get on with drawing. A good instructor will assist students without overwhelming them.

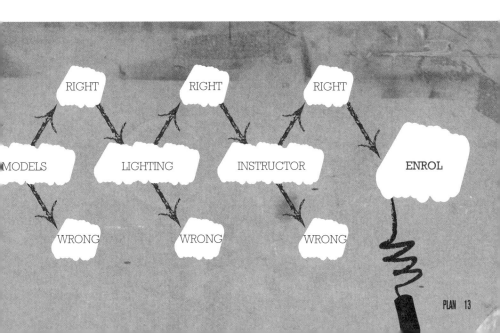

BASIC MATERIALS

craft knife

variety of paper

putty rubber

fixative spray

pencil sharpener

selection of pencils

selection of drawing pens

drawing dip pen

graphite pencil

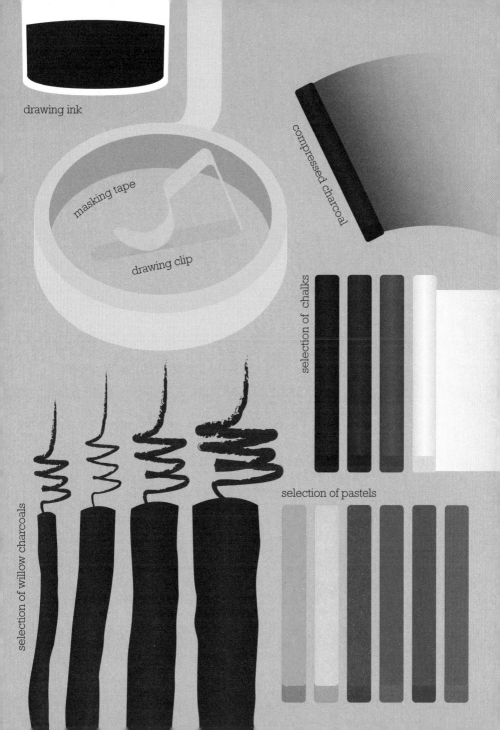

drawing ink

compressed charcoal

masking tape

drawing clip

selection of chalks

selection of pastels

selection of willow charcoals

PAPER

The paper you use for your drawings is just as important as the media you use to draw on them. There is a huge range of paper, but most falls within three broad categories:

Sketching paper: Economical, thin and light; good for quick sketches.

Charcoal / graphite / pastel paper: Heavier than sketching paper and with more texture to hold the medium to the paper.

Watercolour paper: The thickest and most heavily textured paper stock.

Within these categories there are four basic principles to consider when it comes to choosing the paper that's right for you:

Weight: Paper is measured in pounds per ream (lb.) or grams per square (gsm). The 'heavier' the weight, the thicker the paper will be, but this is not an indication of quality. It simply gives you an idea of the paper's strength.

Texture: Paper textures range from smooth to rough, which determines how the drawing material reacts to – and is held by – the paper. As an example, for charcoal you should choose a rough paper that holds the charcoal – if the paper is too smooth, it will smudge or rub off over time.

Acid-free: This type of paper is free from the use of acid in its production. This means it will not yellow over time, so has a much longer 'archival' life when it comes to preserving the masterpieces you create.

Size: The size of your paper is important; if the page is too small you can feel trapped and aware of its borders. Using space will also help you to learn about good composition. The ISO standard sizing is the most commonly used and ranges from A0 (33.1 x 46.8in) to A10 (1.02 x 1.46in).

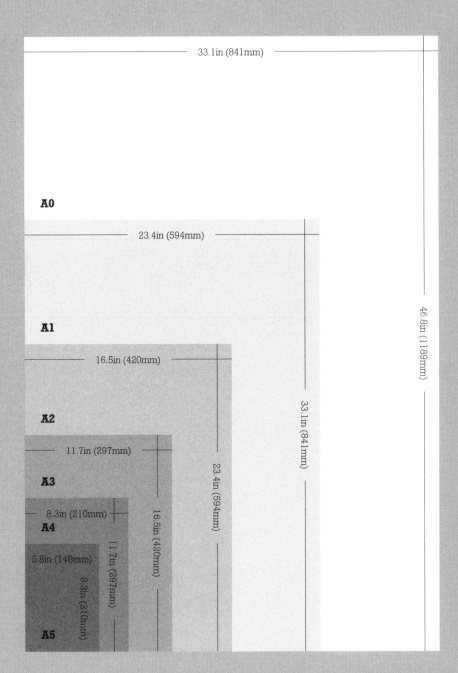

33.1in (841mm)

A0

23.4in (594mm)

A1

16.5in (420mm)

A2

11.7in (297mm)

A3

8.3in (210mm)

A4

5.8in (148mm)

A5

46.8in (1189mm)

33.1in (841mm)

23.4in (594mm)

16.5in (420mm)

11.7in (297mm)

8.3in (210mm)

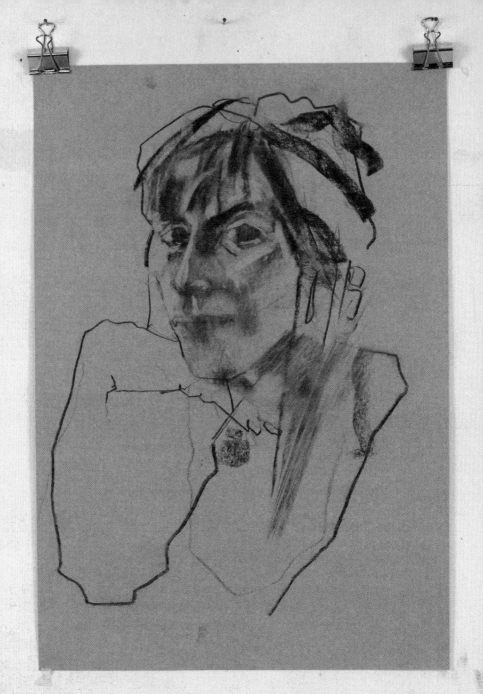

WILLOW CHARCOAL

Willow charcoal has been used since humankind made early cave paintings. It is a beautiful medium for drawing and each piece of charcoal is unique.

GOOD FOR BEGINNERS

Depending on the type of paper you use, willow charcoal can be almost totally removed using a putty rubber. This makes it perfect material to begin drawing with as you can put down marks and move them around as you begin to finish the drawing. It is also a very malleable medium that you can work directly with your hands in an almost sculptural way.

ENDLESS POSSIBILITIES

Willow charcoal comes in a variety of shapes and sizes, which gives you endless possibilities for line and mark making. Big pieces provide interesting options as you draw, allowing you to use the tip for creating lines and the side to cover larger areas.

⏱ 7-MINUTE PORTRAIT

This drawing was made from a pose of 7 minutes, using just a single piece of willow charcoal to explore the different possibilities of line and shade.

COMPRESSED CHARCOAL

Compressed charcoal has a level of hardness that ranges from soft to hard. Soft compressed charcoal is very dark and messy, but is ideal for covering larger areas and creating strong dark lines. As the compressed charcoal becomes harder, so the marks made become finer and sharper.

CREATING DEPTH

Using a variety of different charcoal types allows you to give depth to your drawing. Compressed charcoal is good for going over the top of willow charcoal when you are sure you need to solidify the marks. Once put down onto the page, compressed charcoal is very difficult to remove.

COMPRESSED CHARCOAL LAYER

In this drawing you can see the darker, compressed charcoal over the first layer of willow charcoal. The compressed charcoal is used to make blocks of darker shades in the head of the figure.

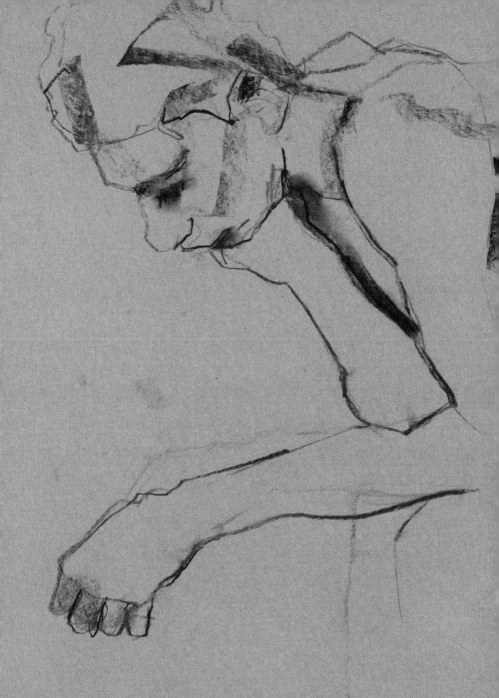

ERASERS

An eraser is not just a tool for removing mistakes – it can also be used to blend and make marks in your drawings. There are several different types of eraser, each with individual strengths and effects:

Putty rubber: A putty rubber is the least aggressive eraser. It removes marks by picking them off the paper, rather than rubbing them in (which can be damaging). Putty rubbers are best used for charcoal drawings, where they can remove and blend the charcoal, creating interesting marks and tones.

Rubber eraser: This is the classic eraser that you may recognize from school. It is best used to remove pencil marks, but also works with charcoal.

Plastic or vinyl eraser: This is a very hard and precise type of eraser that can remove most marks and lines. However, care is needed as it has a tendency to rip or damage the paper if you are too vigorous.

STRESS RELIEF

It's a good idea to keep your putty rubber in your spare hand while drawing. The rubber will not only act like a 'stress ball' while you draw, but the more you move it and squash it, the more malleable it will become, helping you to create mark-making shapes with it.

PUTTY RUBBER DRAWING
In this portrait a putty rubber has been used to 'draw in' the light on the subject's face.

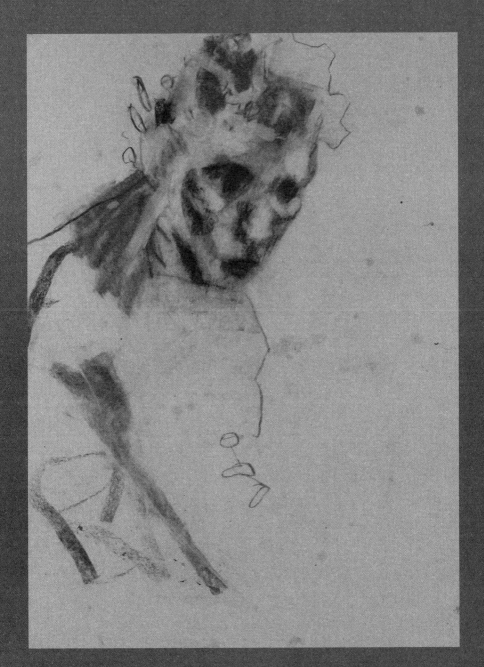

GRAPHITE AND PENCILS

Standard graphite pencils are ideal for sketching, as they are clean and simple. Considered the basic drawing tool, they come in a variety of tones, ranging from **9H** all the way to **9B**. The middle tone in the range is **HB**.

HARDNESS

The higher the **H** (hardness) number of the pencil, the harder the line will be, while the higher the **B** (blackness) number, the softer the line will be. Generally speaking, this means **H** pencils are used more for the lines and small details in a drawing, while **B** pencils are used to add shade and tone.

A GOOD MIX

It is not necessary to have every grade of pencil, but a good selection for your drawing kit would be **4H**, **2H**, **HB**, **2B**, **4B** and **8B**, which give a wide range of hard and soft graphite. Try out different pencils and brands and notice which ones work best for the results you need.

PENCIL CHOICE
Ranging from the hardest, 9H, which produces a very light mark to the softest, 9B, used to create much darker lines.

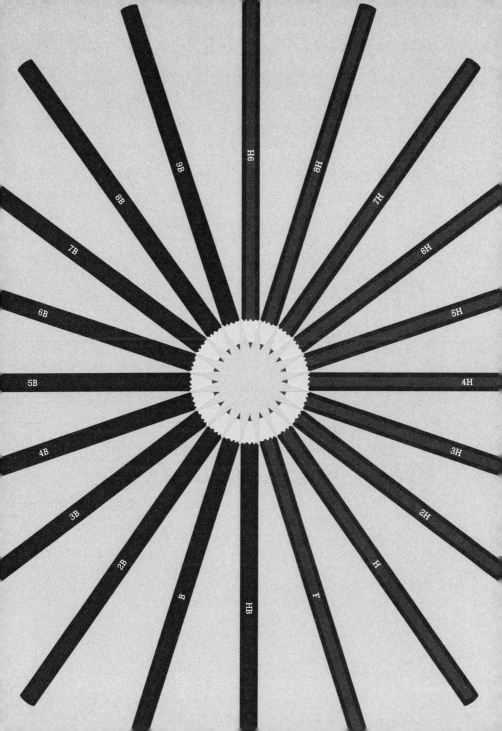

WHITE CHALK

White chalk is a fun tool to use on paper with a middle tone. It is the perfect medium for exercises in drawing light as the lines are seen either as black or white depending on where light is hitting the subject. The white chalk pulls the figure from the darkness and adds depth. It can be used on top of charcoal, to add another layer to your drawing. Similarly, off-white chalk is a good option to use.

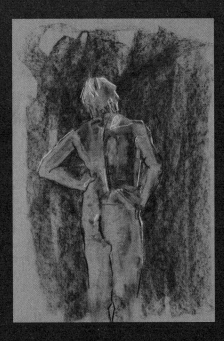

❧ 12-MINUTE TONAL VALUE DRAWING
This drawing (left) was made using willow charcoal and a putty rubber at the beginning, followed by compressed charcoal and white chalk at the end. The white chalk highlights the key angles of the body.

❧ 10-MINUTE POSE
The first layers of this drawing (right) were made using willow charcoal and a putty rubber. The features of the face are emphasized by compressed charcoal and white chalk.

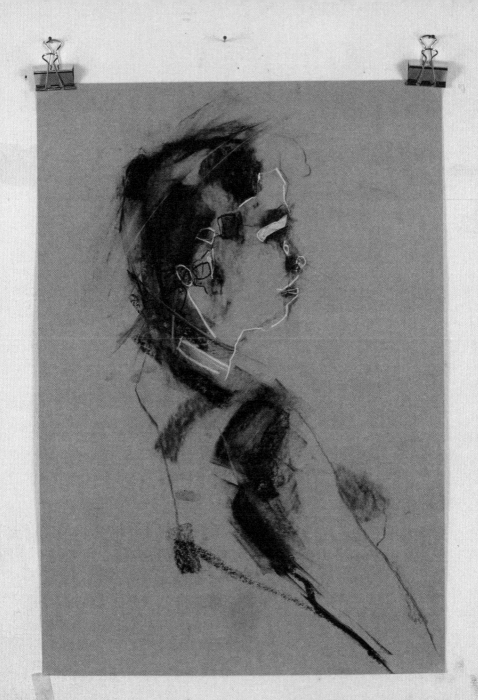

①

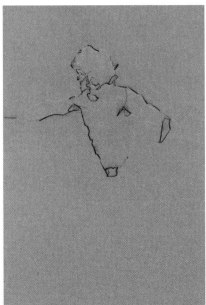

②

③

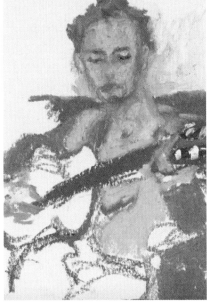

④

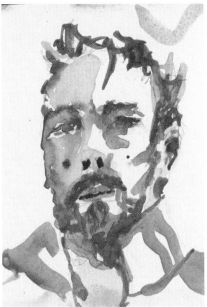

DRAWING WITH COLOUR

It's always fun to add colour to a drawing, but doing so brings new challenges. Here are a few recommended mediums to help bring colour into your drawings:

CHALK PASTELS

Like charcoal, chalk pastels are very immediate in the way that you use them and they are very messy (in a good way!). The colours have a lovely way of blending with each other, but tend to work better with charcoal than oil pastels, since they have a similar 'dry' quality to charcoal, which allows you to use each medium to go over the other.

OIL PASTELS

Oil pastels are messy, direct and closer to wax crayons. Like chalk pastels, they are good for blending, but are far bolder and more expressive. As you hold both chalk and oil pastels in a similar way to charcoal, it is easy to move between them in your drawings.

WATERCOLOUR

Watercolour is not very forgiving and can be difficult to get to grips with at first. However, once you get a feel for it you will find that it is well suited to life drawing as it allows you to work quickly. Watercolour bridges the techniques of drawing and painting: working with large brushes gives you a painterly feeling, while using smaller brushes is very similar to drawing.

COLOUR STUDIES
① *A willow and compressed charcoal drawing, made in 7 minutes. Chalk pastels are applied at the end.*
② *A 4-minute drawing combining blue chalk mixed with compressed charcoal.*
③ *An oil pastel drawing made over 15 minutes.*
④ *A watercolour portrait made over 12 minutes.*

OTHER ITEMS

The range of drawing materials is vast, but beyond your basic drawing kit there are a few other items that could come in useful in your preparation, drawing and aftercare:

STUMPS

Stumps are used for blending charcoal and pencil drawings. They look like a pencil and are normally made out of felt, paper or leather, with each end sanded to a point that lets you blend and smudge. This is like using your finger, but a stump will not transfer any skin oils, which don't mix well with charcoal, to the drawing.

CHAMOIS

A chamois leather is great for blending, smudging and erasing charcoal, pencil and chalk pastels. It's also a good tool if you feel you have overworked areas of the drawing, as it can pull off a lot of layers for you to rework. When the chamois gets dirty, simply rinse it out a few times with warm water and let it dry.

WATER

Water can be mixed with the dust from charcoal to give it a quality that is similar to paint. It can be a lot of fun building up the layers using a variety of brushes, but you will need to use a strong paper if you choose to work this way (watercolour paper is ideal).

Water can also be used on ink drawings. You will have to play around with different pens to discover what works for you, but the ink should bleed when it is mixed with water and bring a whole new dynamic to your drawing. It can also be interesting to use cooled, black tea or coffee instead of water, as this can add a hint of colour to your drawing.

FIXATIVE

Charcoal has a tendency to smudge, so to preserve a drawing you need to 'fix' it using a fixative spray that can be bought from all good art stores. The best way to use fixative is to lay the drawing on the ground outside and spray a light coat over it: the more layers of charcoal in your drawing, the more layers of fixative you will need to protect it. To test whether there is enough fixative applied to the page, touch the charcoal lightly with your finger. When no charcoal transfers to your finger, you know it is protected sufficiently.

MASKING TAPE / DRAWING CLIPS

These tools come in handy if you are using paper from a roll and need to keep it flat on your drawing board or easel. A good-quality masking tape can be easily removed without staining or damaging the paper.

PORTFOLIO / DRAWING FOLDER / DRAWING TUBE

It is very important that you have a way of protecting and transporting your drawings after a drawing session. A portfolio or a large drawing folder is best for storing and protecting your artworks, as it will keep them flat. It is also possible to use a drawing tube, but it's a good idea to give your charcoal drawings a quick spray of fixative before you roll them. Unfixed charcoal can very easily smudge as you roll your paper.

DRAWING BOX

Find yourself a small tin or wooden box for your drawing materials. It is a good idea to keep the box free of clutter and have one that contains just the tools you need, such as a couple of pieces of willow charcoal of varying sizes, a variety of compressed charcoal, a putty rubber and white chalk. Keep the box ordered and organized so you know what you need is inside and ready for the drawing session.

DRAWING SUPPORTS

Life drawing classes will usually provide you with either an easel or drawing board. People using boards tend to be seated at the front when drawing, while those with easels stand behind them. Both offer a different type of drawing experience and you should experiment with each to discover which is more suited to your needs.

EASEL

The benefit of using an easel is that you can use your full body to make a drawing; it opens up the use of your arm and brings more action into drawing. There is a funny dance that develops with some artists when they draw using an easel, and this dance keeps the artist light on their feet and focused on what they are doing. An easel also allows you to take a step back and look at the drawing from another perspective.

Easels can be expensive, but it is far better to have a good-quality, solid easel than one that wobbles. However, before you invest in one, it's a good idea to try using an easel in a drawing class to see if it feels good for you and suits the way you work – not everyone likes working at an easel.

DRAWING BOARD

Although a lot of drawing classes provide drawing boards it is a good idea to acquire your own. This can be shop-bought or you can make your own out of MDF or plywood – a board in the region of 17 x 24 inches (430 x 610mm) is a good size and most hardware stores with a woodwork shop will cut this for you. At least one of the sides of your drawing board should be completely smooth and clean to prevent unwanted bump or lump marks on your drawing.

OTHER FACTORS

There are many other factors for us to consider when we are drawing. At the beginning keep it simple, but be aware of the many subtle external factors that can influence you when drawing. The more you draw the more these factors will appear.

LIGHT

Light is a very important element. Firstly, you should make sure that you have good light on your paper. It is best when the light source is coming from above, as this will prevent any distracting shadows from being cast across the page. During a life drawing session it is also beneficial to have a selection of lights that can be adjusted for the model.

TIME

When you're drawing you experience time in a very different way. It can be useful to try and keep a check on the time during your drawing sessions, especially if you are working from a model.

In a life drawing class, the instructor keeps an eye on the time and communicates this to the model. At the beginning of the session, there might be a number of short, one-minute drawings. Short poses generally allow the model to be more expressive and adopt more demanding positions. As the poses get longer, the model tends to relax, sometimes becoming so relaxed that they fall asleep, bringing a new level of intimacy.

MUSIC

Mixing music with complementary lighting can have a huge impact on your drawings. Consciously letting the mood of the music influence your lines and marks is a good way to direct your expression. You can even incorporate time into the mix by making a music playlist that assists the mood you want to portray.

LIFE DRAWING

Life drawing has been practised for centuries and is the basic form of training in most art schools. It has recently experienced something of a resurgence in popularity, with lots of people starting their own classes and groups. Drawing in this way will help keep your observational and drawing skills sharp and will allow you to explore and play without the pressure of creating a 'finished' work.

MEDITATION

The very nature of life drawing can be considered a form of meditation. In a life drawing class there is not much time for thinking, as the artist is focused totally on that moment. It is a good place to switch off from the 'noise' in your life and to let all the things in your mind settle. Sometimes, the best life drawing classes are those where there is not much instruction, but a more concentrated silence that allows everyone to focus on their work.

THE NAKED BODY

As the model is normally not clothed for the drawing session it can be slightly uncomfortable if you've never been to a class before, but, after a few poses in a good class, you will see how natural the process feels. Because of the race against time trying to capture the figure, drawings that come from a life drawing session convey the very same life and feeling of the time experienced: when the pose is finished, the drawing is finished.

⏱ 8-MINUTE POSE
In this drawing, the artist has built up different layers with willow and compressed charcoal. Notice how the compressed charcoal reworks some of the original willow lines to define the figure.

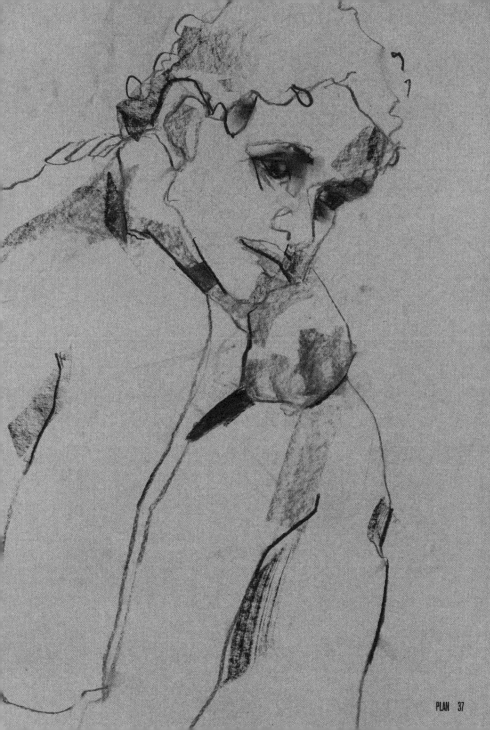

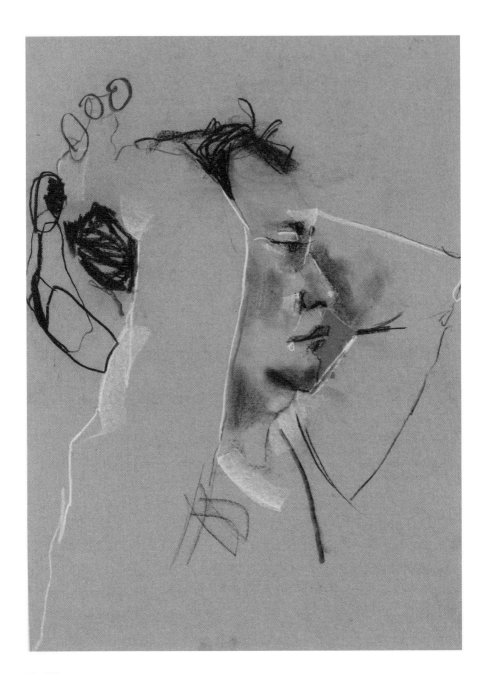

CREATING ART

In the past, life drawing was mostly undertaken as a study for a larger work or as an exercise to understand observation and mark making. Today, however, you will see more and more drawing exhibitions being set up that showcase life drawing as 'finished work'. What seems to be becoming more and more interesting to the contemporary eye is when the artist either intentionally or unintentionally takes the opportunity to distort the elements of what they see or to express the elements that they are drawn in by.

⏱ 10-MINUTE CHARCOAL DRAWING

Notice how this pose (right) is incomplete; this is because the artist ran out of time. You can see that the focus was on the head and shoulders, using willow and compressed charcoal to cover the paper, and the putty rubber to pull out the figure.

⏱ 12-MINUTE LAYERED DRAWING

The artist has used a variety of layers and materials to stunning effect. Willow charcoal maps out the figure and compressed charcoal and white chalk pull out the dark and light lines. The negative space between the elbow and face is blocked in with orange chalk. The strange kind of distortion of the suggested fingers gives an immediate and fast quality to the drawing.

PORTRAITS

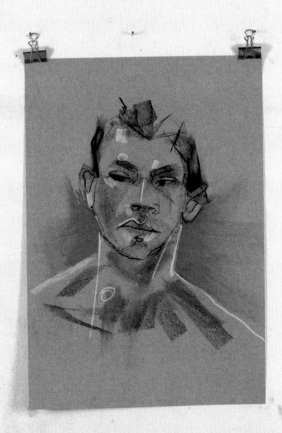

Portraits are a wonderful exercise to practise outside of your drawing classes. The challenge is to catch a likeness of a person, but experience and practice are needed to draw what you see, rather than what you think you see.

THE ART OF LOOKING

If you ask a child to make a portrait they will look mostly at the page. They construct the image in their mind and draw what they think they see, using the model as a reference. However, to catch that magic likeness, an artist must concentrate on transmitting – as closely as possible – what they see onto the page; they need to practise the art of looking.

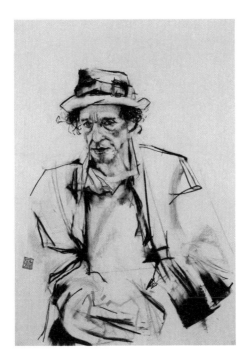

🕐 **9-MINUTE PORTRAIT**
*Notice (left) how the red chalk
behind the head separates the
figure from the background, giving
a sense of depth to the portrait.*

🕐 **5-HOUR PORTRAIT**
*This longer portrait (above) uses
willow charcoal and a putty rubber
to shape the figure. Compressed
charcoal and chalks are used to
define the facial features.*

MIRROR SELF-PORTRAITS

One of the best ways to practise looking is to make self-portraits using a mirror. This
removes the pressure of having a model, and gives you the chance to explore how
a face is constructed and to develop a portrait over a timescale of your choosing.

DRAWING FRIENDS

As you develop, try setting up portrait sittings with friends and family. You can make it
as short or as long as you like, perhaps even making a day of it. Invite the sitter of your
choice, make a nice lunch and create a comfortable atmosphere in your home. It can
become a very different way to spend time, but you will find there can be something
magical in this experience.

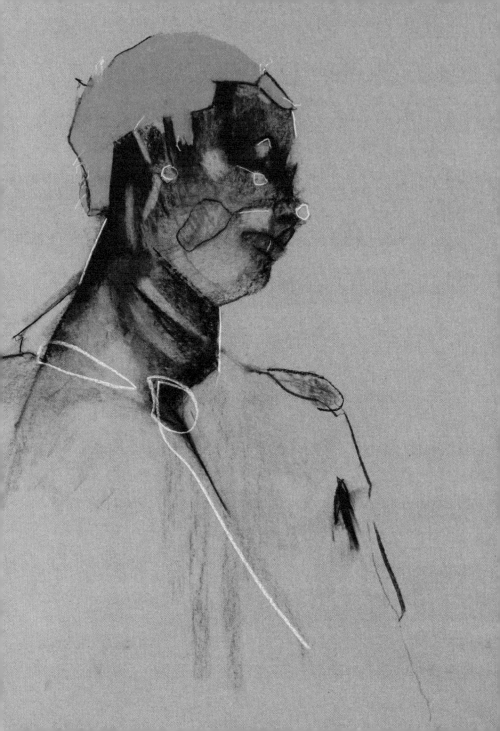

MAKE

The drawing process can be broken into two parts: observation and mark making. The two are inextricably entwined, so in order to enhance your mark-making ability you will also need to enhance your observational skills. Like any other learning experience, the key is to keep it interesting so you enjoy progressing and developing.

LINE AND TONE

The key components of drawing are line and tone.

Lines are something that you can relate to from your first drawings as a child, as they are instinctively used to create form and shape. They are the marks you make to represent something and the basic way to compose or sketch what you see in front of you.

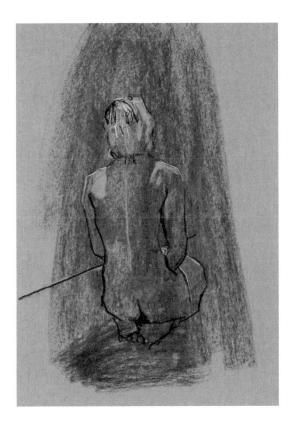

Tone refers to the light and the dark within a drawing. It is what gives a drawing a three-dimensional quality and a sense of realism. Everything you can see depends on a certain amount of light hitting it in order for it to appear, as well as shadows to give it form. So, while lines create the outline of an object, it is tone that gives it a sense of solidity.

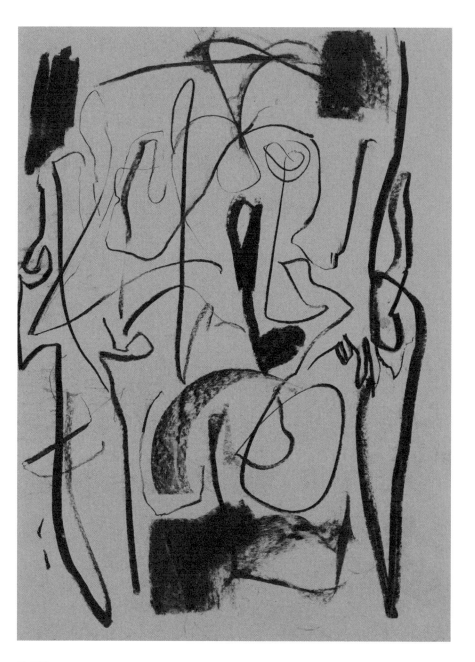

LINE

You can think of lines like language. Just as a poet becomes a master of the sentence, creating meaning through words, an artist masters the drawing, creating meaning through line; lines are the letters in the visual alphabet. Some of the lines at the start of a drawing might be light and careful, for example, mapping out form and shape. However, lines drawn later on might be expressive, heavy and fast; each has its own personality and forms relationships with the other lines around it.

LINE CONSIDERATIONS

① Be economical. Leaving out lines invites the viewer to drift into the world of the drawing.

② Use the full range of your wrist and arm when drawing: different parts of the arm and wrist bring a natural variation of line. Avoid sticking to the ways you use your hand in writing.

③ When you are sure of what you see, press down and make a decisive mark; when you are less sure ease up on the pressure. This automatically produces different lines.

④ Vary your drawing speed, since working quickly will produce different lines from those created when you are working slowly. Music can help you to explore these variations.

LINEWORK
This drawing shows some of the different lines that can be created using a single piece of willow charcoal.

TONE

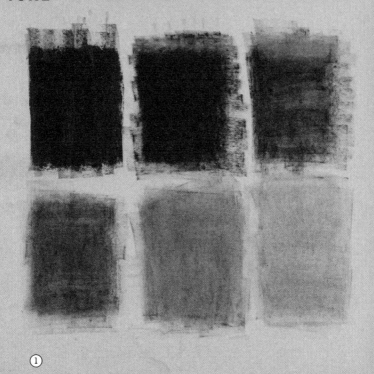

①

When you arrange your subject(s), consider and play around with the lighting in order to create contrasts on your subject. It is good to get into the habit of determining where the light is coming from, how it is falling on the subject and what shadows it is creating. The greater the contrast – the range between the brightest highlights and deepest shadows – the more the subject will stand out in the drawing. Conversely, lower contrast will mean the subject sits back or perhaps even becomes lost in the composition.

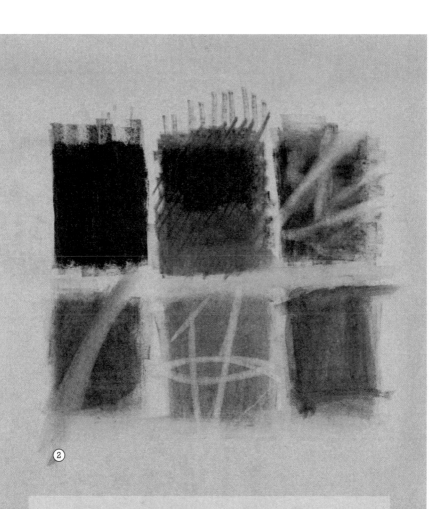

②

DARK TO LIGHT

① *A good exercise in tone is to use willow charcoal and compressed charcoal and see how many different tones you can produce. Start from the very darkest and work up to the lightest, feeling the different pressures needed to adjust the tone.*

② *You can also experiment with blending charcoal to change the tone, create shadows and give form to your drawings.*

⏱ 20 mins DRAWING WITH LAYERS

Think of a drawing as being comprised of layers of lines and tone that work together to create an image. When you feel like progress has slowed, or you are beginning to overwork a drawing, this is often the time to switch to a new layer. This is a great way to keep your drawings alive, as it will stop you overworking a picture and destroying the life in it.

INGREDIENTS FOR DRAWING

To ensure that you can switch seamlessly from one layer to the next, it's a good idea to have your putty rubber and other materials ready when you need them. Think of your materials as being like the ingredients you need for a soup: each can add a different flavour.

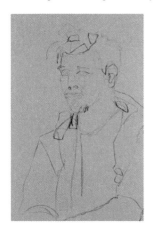 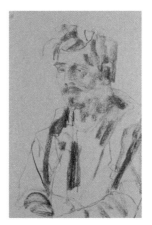 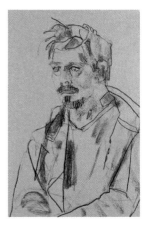

① 0-4 MINS - LINE DRAWING WITH WILLOW CHARCOAL

For the first 4 minutes, lightly map the lines of the subject on the paper. This step is about 'feeling out' the drawing. Nothing is permanent here. If you use willow charcoal for this step it will be easy to correct as you progress.

② 4-7 MINS - ADDING TONE WITH WILLOW CHARCOAL

Look at the figure and put down blocks of shade where you see shadow, using the side of the willow charcoal. Don't worry if elements of the drawing look distorted at this point – you are still exploring and nothing is permanent.

③ 7-10 MINS - DEFINING LINES WITH HARD COMPRESSED CHARCOAL

Working with hard compressed charcoal creates lines that can be difficult to remove. Place the details and try to get the relationships between the subject's features correct. To capture the resemblance of a figure is important, but don't put too much pressure on yourself.

LAYER EXERCISE

The step-by-step exercise shown here demonstrates how a drawing can be built quickly in layers using charcoal and chalk. As you develop your own drawing ability – and become comfortable with the materials you choose – try to be aware of what your steps are. They may differ slightly to this example, but understanding them will help the drawing process become more automatic.

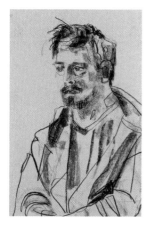

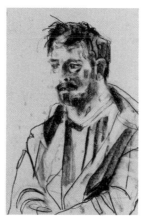

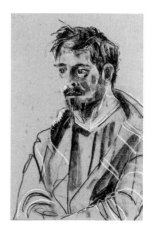

④ 10-13 MINS – DEFINING TONE WITH SOFT COMPRESSED CHARCOAL

Using the side of a small piece of soft compressed charcoal, build up the tone from earlier. Soft compressed charcoal is darker and can be messy to work with, but don't worry about finger marks or accidental marks – these elements can be removed at the next stage.

⑤ 13-16 MINS – PULLING OUT THE LIGHT WITH A PUTTY RUBBER

Use a putty rubber to pull out blocks and lines of light to add a wider range of tone to the drawing. Scan the figure for light and make shapes with the putty to replicate this.

⑥ 16-20 MINS – PICKING OUT HIGHLIGHTS WITH WHITE CHALK

The last 4 minutes should be spent using white chalk to pick out the brightest details you see reflecting off the subject and 'tie up' the drawing.

DRAWING THE HEAD

The head is something that beginners fear the most. You can find a lot of articles in books or online about 'the general proportions of the head', with lots of grids, measurements and mathematics, but the problem is that it's purely theoretical – in reality, every head is different!

DRAW WHAT YOU SEE

The key to success is to draw what you see, rather than what you think you see. It takes a little time to put all the pieces in the right place, with the right distances between them, but it is not as hard as it seems. A good exercise is to make a self-portrait with a mirror. Not only is this a

The following three-step demonstration shows a simple approach to drawing the head – as before, the face is constructed in layers. This is a short pose designed to achieve a striking likeness; sometimes these short poses can be more exciting as you rush to record something that is true of the face you are looking at.

① 0-3 MINS
Start with willow charcoal. Lightly place the head and mark down some of the features.

② 3-6 MINS
The second layer introduces contrast and shade using darker compressed charcoal.

③ 6-9 MINS
The third and final layer picks out the highlights with white chalk.

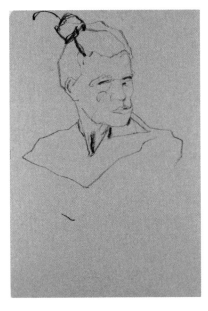

①

great way to practise without any early embarrassment, but it will also give you the opportunity to really look at what it is you are drawing. You will be amazed at how you really appear!

PERSEVERANCE

Try not to be too hard on yourself and try to find something successful in each attempt. After a while you will start to understand the individual harmony of the head through looking. Even the most skilled artists have times when the likeness gets lost, but on those rare occasions that you successfully catch something, there is immediately some magic injected into your drawing.

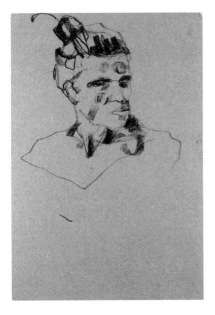

②

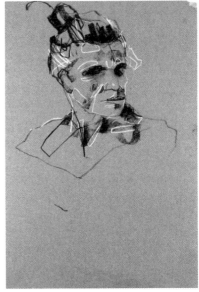

③

ELEMENTS OF DESIGN.

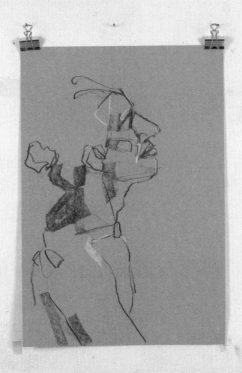

The term 'elements of design' refers to a number of theoretical ideas relating to drawing and design in general. You have already seen two of these elements – line and tone – but there are others that are important to consider. However, while there are a lot of interesting theories in this family of concepts, they can be a little overwhelming when you're starting out. It's also easy to fall into the trap of concentrating on the theories instead of the act of drawing itself. So, rather than worrying too much about the theory before you begin, make some drawings and then see how these elements affect them.

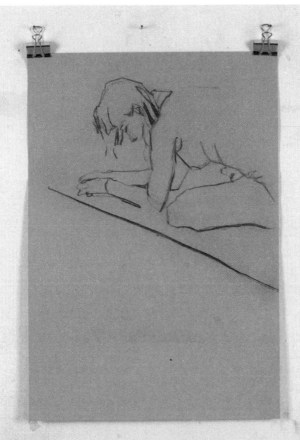

① COMPOSITION

Composition is about the visual order of the image, or, more simply, how you decide to lay the picture out on the paper. The great thing about life drawing is that you often don't have too much time to consider the composition. Because you have to work quickly, drawing comes first and it is only afterwards that you can see the quality of your compositions. This allows you to develop your compositional skills and learn from your own natural explorations, rather than worrying too much while you're drawing.

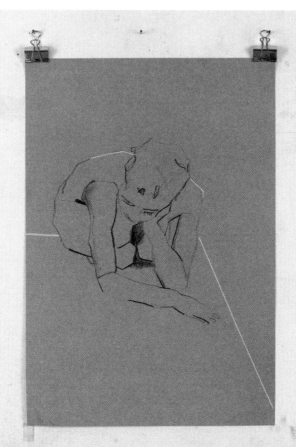

② PERSPECTIVE

Perspective is something you can use to lead the eye to a focal point in the drawing. In this example you can see how the simple line from the stage that the model is standing on suggests room for the subject to inhabit. You can play around with this in your own drawings by finding a line in the room that is important and gives the drawing a deeper sense of space.

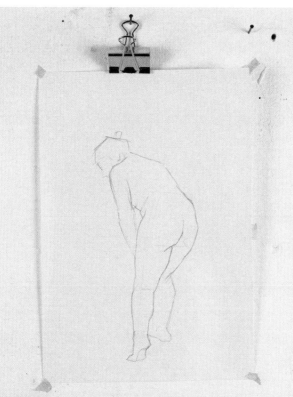

③ PROPORTION

'My proportions are all wrong!' is something you hear a lot in life drawing. If the proportion of one or more elements to the rest of the figure is weak, the viewer will be drawn to it immediately. There are a lot of ways that you can measure the subject to help keep everything in proportion, but learning from your mistakes is perhaps the best solution. One tip is to compare the proportions of the model to your drawing, throughout the process.

Avoid making the subject larger than life size. It is much harder to draw the human head and keep the features in proportion on a larger scale. However, as you become more confident it can also be fun to deliberately play with this idea of distortion, so don't be afraid to know the rules and break them!

FOCAL POINTS

In some drawings you see what is called a 'focal point'. This is the part of the drawing that the viewer's eye is led towards. Before you start drawing, take a moment to look at the subject and find the detail that you feel is most interesting. It might be a gaze in the eye or the line of the leg, but whatever draws you most is where you can start your drawing – this is your focal point.

DIRECTING THE EYES

The focal point is your base and you can work the rest of the form around it. In timed drawings, some areas are built up more than others, so you may notice that you return to the focal point within your drawing, attempting to refine it more and more. This natural development can give dynamism to the drawing.

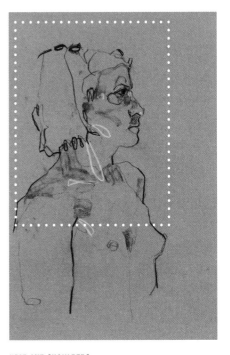

HEAD AND SHOULDERS

The focal point in this 6-minute drawing is the face and the shoulders, while the hair and lower torso are basic and undefined. The contrast between these areas brings a certain dynamic to the drawing; it opens the portrait up for the viewer and leads them in. It is worth noting that the longer you have for a pose, the greater the risk that you will 'fill in' all the details and somehow leave your drawing looking flat.

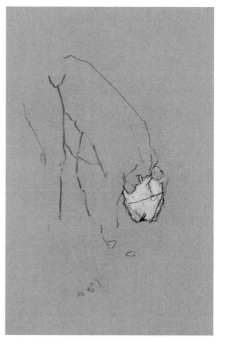

CROPPING

Play around with where you start your drawing and let the edge of the page naturally crop your composition. Here you can see how the crop adds intensity to the image.

LESS IS MORE

In this 6-minute drawing the artist excluded a lot of the lines so the viewer could 'see' them with their imagination. Not revealing everything can enhance how the viewer reads a drawing.

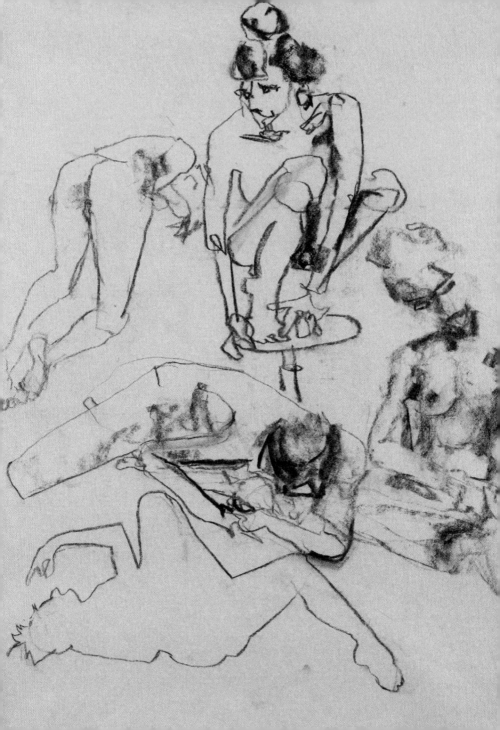

PLAY

Drawing is an exercise that settles all the noise in your mind, so when you create your drawings try and see them like meditations. You should be so focused on transmitting what you see with your eyes to your hands that you bypass your mind. When they begin drawing, a lot of people start to criticize themselves after just a few lines. This is a big mistake, as you are immediately closing the door on this wonderful experience. Instead, let go of your judgements and expectations, and allow your intuition to lead you.

The following chapter contains a series of exercises that you can incorporate into life drawing sessions or practice outside a class, using a friend or object as a model. These exercises will not only train your powers of observation and drawing skills, but they will also open you up to different techniques, which will allow you to see ways in which you might like to develop your style. Consequently, the more you play and incorporate these exercises into your drawing sessions, the more progress you will make.

FIVE POSES: ONE MINUTE EACH

This is a great way to warm up, free your drawing hand and connect with your subject. The aim here is to try and record the full figure in a single minute. With such a fast pose you should surrender the idea of making a detailed resemblance and aim to capture the gesture and essence of the model, nothing more.

The model should change their pose after one minute and the exercise is then repeated until five sketches are completed. These one-minute segments will train your eyes to see and work fast by looking more at the subject than the page.

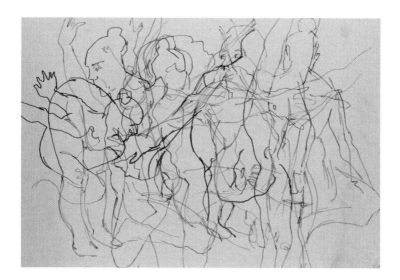

◷ FIVE 1-MINUTE POSES

These drawings look full of energy because they had to be captured so quickly. Placing all the figures on the same page tells a visual story.

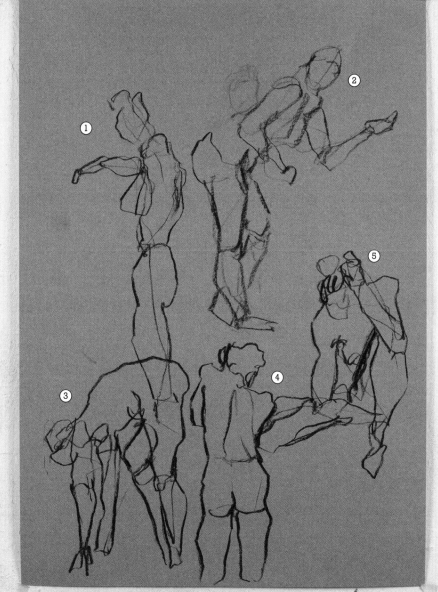

⏱ CONTINUOUS LINE DRAWING

This exercise involves using a single line to describe a model or an object in 3 minutes. When you are sure of what you see, you should push down on the charcoal, pencil or pen, and when you are less sure you should ease off on the pressure, but you should never take the drawing tool off the page. You are searching for the subject using the line and when the time is up you should be able to trace the journey of the drawing from the beginning to the end.

This exercise develops your vocabulary of different kinds of lines, which will add to the overall drawing. It trains the eye to connect and construct the form as a whole.

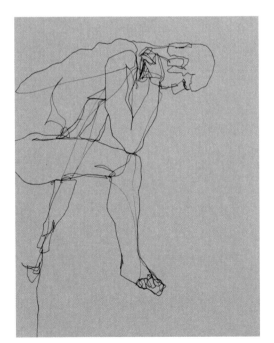

🕐 3-MINUTE CONTINUOUS DRAWING
Drawing with black ink, notice how the artist returns to the area between the head and shoulders. This central point connects the whole drawing.

🕐 3-MINUTE CONTINUOUS POSE
The continuous line never breaks, using the curvature of the body to work the line from the top of the head to the feet and back again.

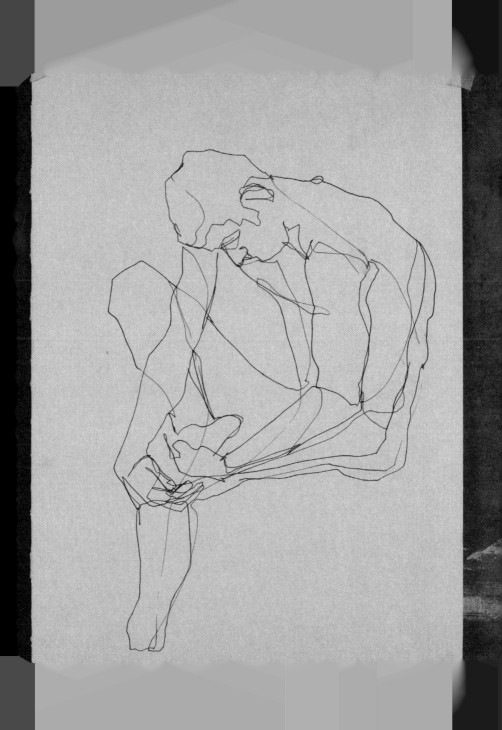

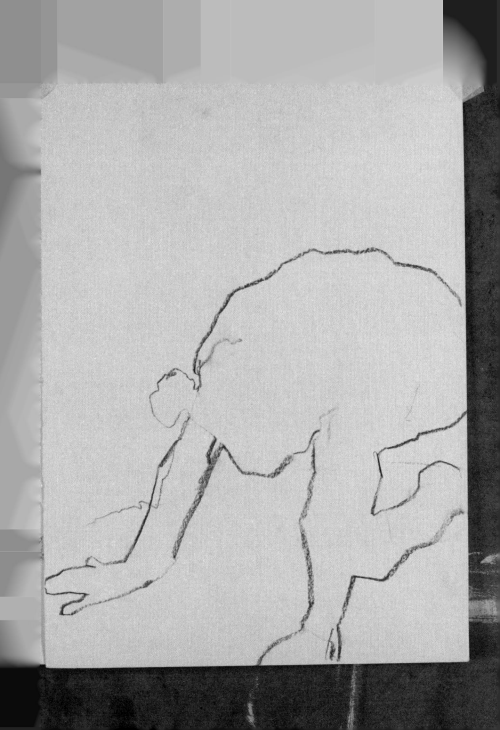

⏱ CONTOUR LINE DRAWING

In this exercise you are exploring the exterior lines that surround the form. In short, you are drawing the outline of the figure in 3 minutes. Don't focus on any details, just the outlined shape of the subject.

This contour line exercise helps you build form into a drawing and is an excellent way to work on proportions in a very non-technical way. From this exercise you will see your intuition naturally work out problems, so you are learning by doing!

🕐 3-MINUTE CONTOUR LINE DRAWING
Taken from a life drawing session. The artist traces the surrounding lines of the figure with willow charcoal, capturing the outline of the human form, almost in silhouette.

NEGATIVE SPACE
This drawing of the outline of a pot plant is a good example of what is meant by a contour line drawing. The negative space is filled in with charcoal to emphasize the contour.

⏱ TONAL VALUE DRAWING

With the following exercises you will be exploring shade and tone rather than the line. To start with, make a 3-minute study that doesn't use any lines at all to compose the subject. Instead, use the side of the charcoal to build up areas of shadow that pull out and compose the figure.

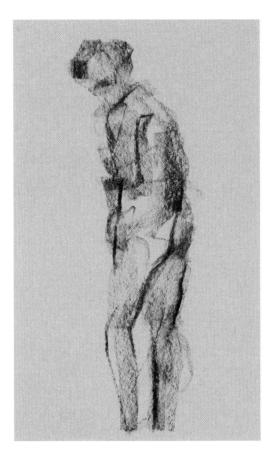

🕐 3-MINUTE TONAL DRAWINGS

These poses build up the form using tone only. Notice how the different tonal values are created naturally by the charcoal. If you squint your eyes a little when looking, you can somehow see the form better. Squinting while drawing can be very helpful and can simplify lines and shade that make up the form. It is a fun exercise to play around with.

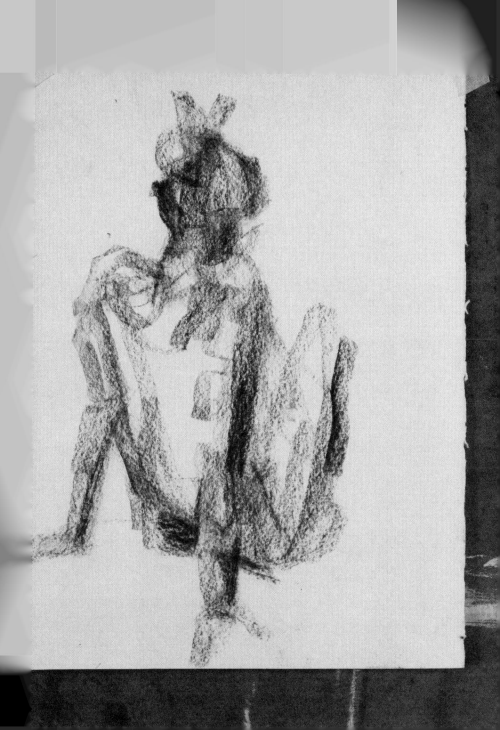

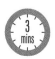

NON-DOMINANT HAND DRAWING

Unless you are ambidextrous, making a 3-minute drawing with your non-dominant hand is a wonderful way to relinquish some control naturally. The imbalance between your hands and the lack of 'flow' within your weaker hand will bring new types of line for you to consider. After a short time practising this exercise you might be surprised at just how much more control you develop in your non-dominant hand and how this can inform your drawings.

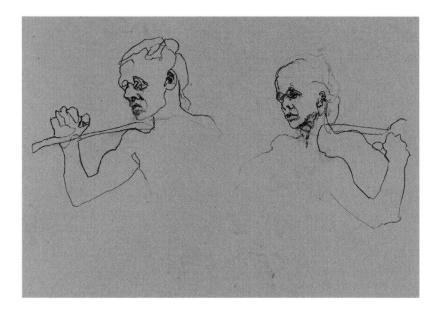

⏱ TWO 3-MINUTE POSES
Within a 6-minute timeframe, the artist made two drawings on the same page using both the right and left hand.

⏱ 3-MINUTE POSE
This drawing was made using the non-dominant hand. With each attempt you'll discover something new in your work.

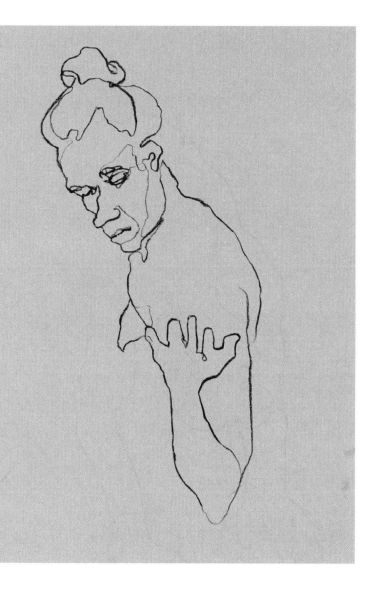

⏱ BLIND DRAWING

The key to drawing from life and from a model is to look at the subject much more than your paper. Around 70 per cent of the time should be spent looking at the model and 30 per cent on your drawing. If you spend too much time looking at what you are drawing, your mind is 'switched on' and you may start to draw what you think you see. This is not what you want. Drawing from life is about heightening your sense of observation, and with experience you will begin to feel this develop.

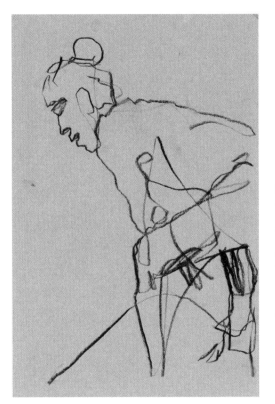

⏲ 3-MINUTE BLIND DRAWINGS

Drawing blind is the ultimate exercise in letting go and focusing on your subject. For the entire duration of the 3-minute pose you should not look at your drawing once. This kind of drawing might look very abstract at first, but it is a great way of training that will help you focus on what you see and develop a responsive quality of line. Have fun with it and be aware how much more noticeable the small details and the shapes of the body really are. This will make your lines far more believable.

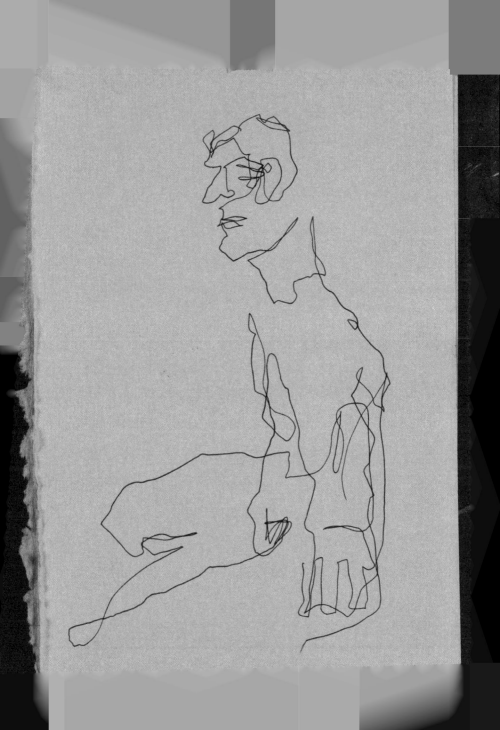

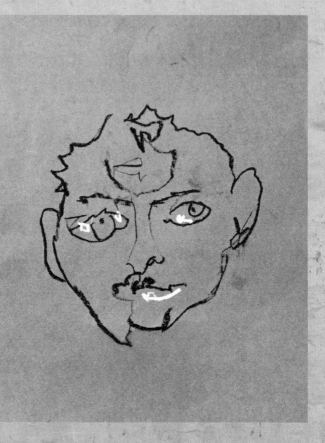

⏱ 6 mins BLIND DOUBLE PORTRAITS

This exercise involves two people sitting in front of each other, drawing a 'blind' portrait, never looking down at their paper. Usually when you communicate with others, you don't maintain full eye contact – it is too intense, even if the tone of a conversation is light.

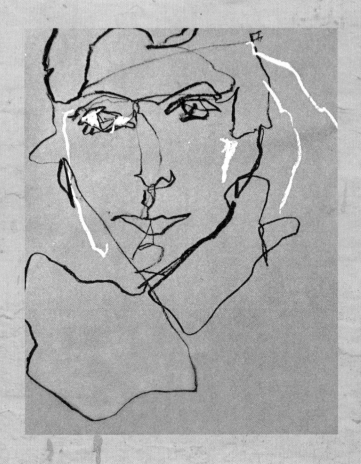

REFLECTIVE EXPERIENCE

In these two drawings we see an attempt to capture something of the other person. By not looking at the page while they are being made, a distorted portrait is achieved. The purpose of these exercises is to develop the skills of observation. This exercise forces you to step into a very intimate world without using words. It can be a highly reflective and existential experience, and a lot of portrait artists become very attracted to this way of working. To start with, try this exercise with a friend or family member.

WHITE CHALK ON DARK PAPER

For this 3-minute exercise you should work with a piece of white chalk on a dark sheet of paper. The aim is to create line and shade with the chalk by drawing only the light of the subject. This exercise will make you aware of selective lines and result in a subtle drawing that is sometimes quite abstract.

◕ 3-MINUTE POSE

This drawing has captured a figure lying down, in white chalk on brown paper. The white chalk highlights the angles of the body.

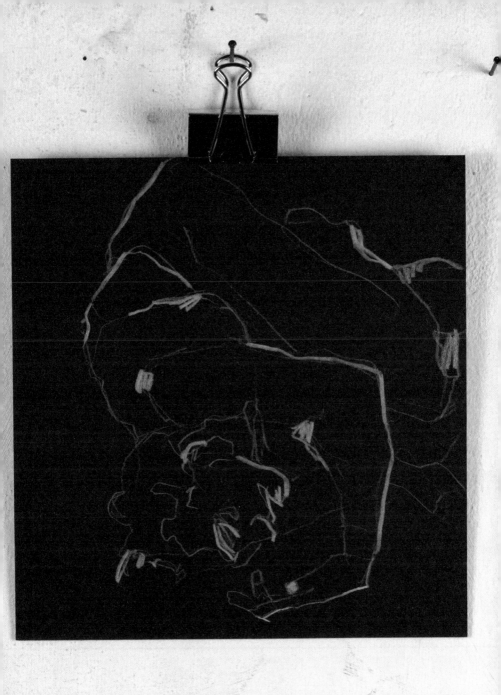

FOUR-STEP COMBINED DRAWING

In this exercise you will build up a drawing over a 15-minute period, using the techniques you have learned previously to create shadow, line and light.

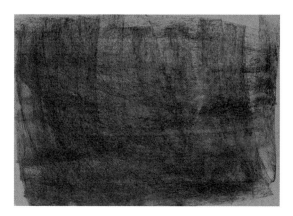

① 0–1 MINS

The first thing you need to do is cover the entire page using the side of your charcoal.

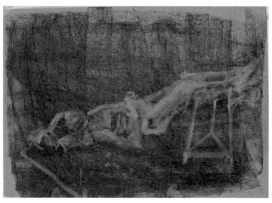

② 1–5 MINS

For the next 4 minutes use a putty rubber to pull the subject out of the dark. Take your time to work out the proportions and develop the tonal values.

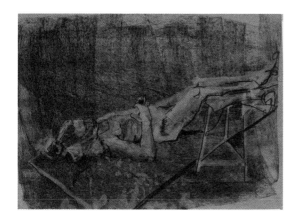

③ 5-10 MINS

The next 5 minutes should be spent using soft compressed charcoal to define the lines of the subject. This is a line and shade layer in which you establish the dark lines and shadows that you see. You can also use the putty rubber to shape and tighten the drawing.

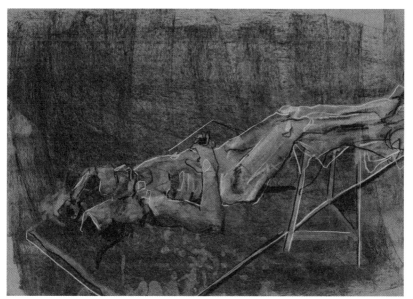

④ 10-15 MINS

The final 5 minutes should be spent using white chalk to add light. Notice how this use of tone gives the drawing a three-dimensional feel.

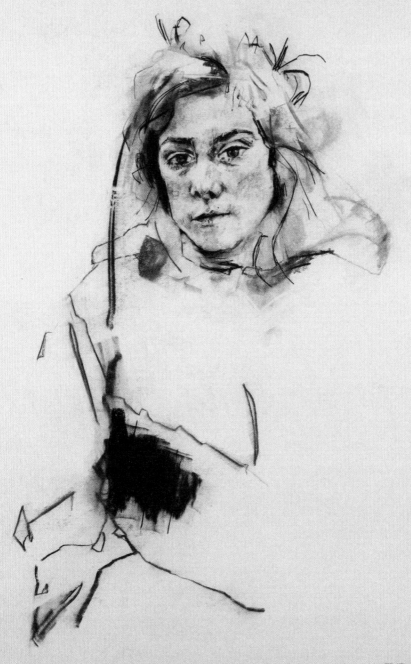

GROW

With time and practice you'll become more comfortable and confident approaching the page. In a sense, when you reach this level you are 'safe' – you have put in the practice and you know what you are doing.

At this point it is a good idea to go through all of the drawings you have collected so far, and arrange them so you can see the path of your development. It is very satisfying and important that you not only realize what you've achieved, but also see your journey so far. This will help you with the next step, which is to choose the direction you wish your work to go in; where do you want to take your drawing now?

In this final chapter you will find advanced techniques and suggestions for projects that will inspire and encourage your self-directed drawing path.

DRAWING MOVEMENT

The dance world has always attracted artists, and vice versa. When the artist uses drawing as a way to document movement it can take their work to a new level.

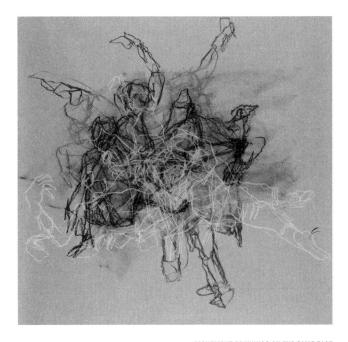

MOVEMENT DRAWINGS ON THE SAME PAGE
The first drawing is put down on the page with willow charcoal, tracing the dancers' movement over 4 minutes. We can see the movement of the arm at the top of the page. The second drawing is overlayed using white chalk over 3 minutes. We can barely make out the movement from a standing pose to a lying down position.

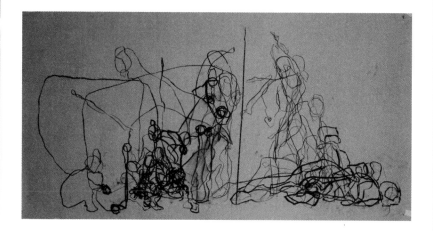

The drawing above shows two different movement exercises divided by a line. On the left, we observe the figure shift from sitting to standing, traced as they move. On the right we can see the figure move from standing to lying.

SCORE DRAWING

Dancers usually work within a structure called a 'score', which is a narrative of their movements. The chaotic drawing above is from a simple score where a dancer was exploring the room, walking from one end to the other, picking up oranges and letting them drop. The large vertical lines in the drawing are the points at which the oranges dropped.

A LIFETIME'S WORK
These exercises can open up windows in your practice that might lead you somewhere else. That is the beautiful thing about drawing: there is enough to keep you busy for a lifetime if you choose.

STANDING-TO-LYING POSE

An interesting exercise is the standing-to-lying pose. It involves the model holding a pose while standing for 3 minutes. Then, very slowly, they should move to a lying position, still maintaining the pose.

PRACTICE

This is a fun exercise to practise with a friend, when you both take turns to be the model. While in the drawing position it can feel like running a race to document the observed scene.

STANDING TO LYING

Notice the different steps in this drawing, which have been recorded as the pose progresses. Most of your attention should be on the model and not the drawing. The inclusion of movement is a great way to develop your speed and powers of observation, which may in turn feed into your approach to drawing later on.

WORKING ON LOCATION

Taking a long walk, stopping at different places and making a quick sketch of what is around you, will get you out of the studio and onto the streets. It's a great place for inspiration when things get stale indoors and this spontaneous way of drawing will also help keep you 'visually fit' and potentially spark new ideas for your drawing projects.

SKETCHBOOK

So you are ready to capture and record, it's good practice always to have a small sketchbook with you. You should also choose a material that is easy to carry around and work with, such as a pen or pencil – charcoal can be very messy on the go!

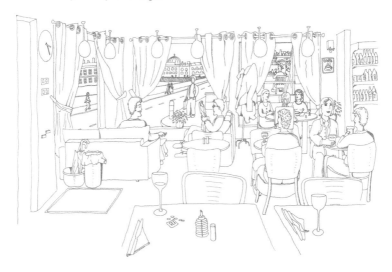

⏱ 15-MINUTE OBSERVATION

This cafe scene, made over 15 minutes using a simple blue biro on paper, captures a moment in time. Drawing directly from real life presents different challenges to life drawing.

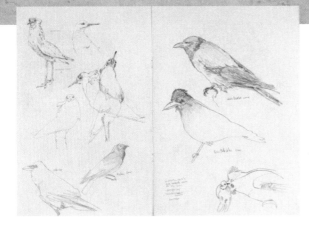

VISITING GALLERIES

Making gallery visits to look at how other artists explore their ideas and present their work is good for your own development. At art school, students have always been encouraged to make trips to museums as well, where they can draw directly from sculptures and paintings. The benefit of drawing from a sculpture is that you have a model holding a pose for as long as you want, without any pressure, while drawing paintings by the Old Masters will teach you a lot about composition and other elements of design.

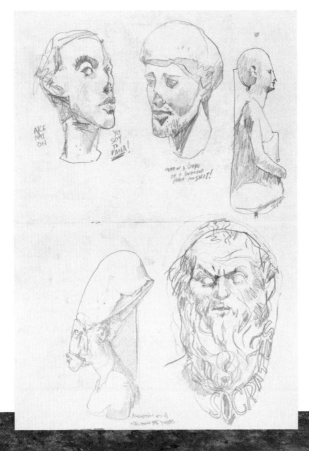

FROM THE ARTIST'S NOTEBOOK

These drawing were made during a museum visit. Museums are a good place to sketch as they are often peaceful and quiet and offer a variety of models, such as these birds, top, and sculpted statues, bottom.

EXPERIMENTING

Experimenting is one of the most important things you can do if you want to progress with your drawing. It helps you push your drawing skills in new directions, rather than sitting comfortably and simply repeating what you've already learnt over and over again. Drawing is an endless road and should be treated as one; there will always be excitement if you push your drawing as far as you can.

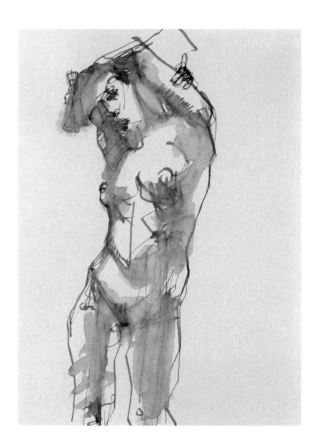

🕑 **4-MINUTE POSE**

This drawing, from a life drawing session, was created using red and black ink. Coffee was added afterwards to make the ink bleed, creating very unpredictable marks.

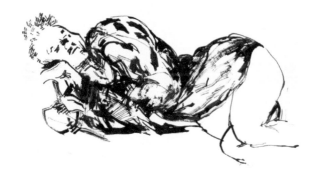

GONZÁLEZ

① TWIG AND INK

This is a great exercise for your early experiments. Go outside and find a fallen or broken twig. Try to be selective, as this twig will be your drawing tool. Then, working with Indian ink and paper, dip the twig into the ink and start to draw. This can be a messy and unpredictable way of working, but that's the point: you will be forced to improvise, and in doing so will explore and develop your line vocabulary.

◔ 4-MINUTE DRAWING

This drawing was made using black Indian ink and a single twig from a tree. This medium offers a great range of marks with different tones and textures.

② COLLECTING DIFFERENT PAPER

Another way to keep your life drawing fresh is to make a habit of collecting and searching out different types of paper. The individual qualities of the paper will force you to explore alternative approaches to your pictures, which will in turn encourage new discoveries and techniques. Alternatively, simply changing the size of the paper you use can lead to different working methods.

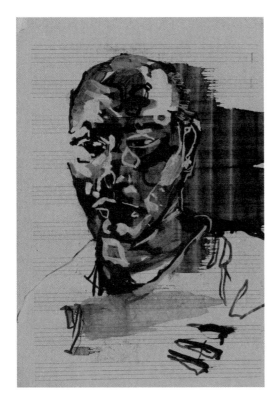

MUSIC PAPER DRAWINGS
This drawing was made on very old music paper. It was started with ink on paper. Afterwards, the artist used a ruler to drag wet ink from left to right over the drawing. Finally, watercolour was used to finish the illustration.

③ INK AND COFFEE DRAWING

Using calligraphy ink pens with ink that bleeds when liquid is applied can result in beautifully expressive drawings. However, rather than using water to bleed the ink, experiment with black coffee, tea and other liquids to introduce colour after the drawing has been made. Don't worry if you destroy some of your drawings at the start – it will be worth it for the ones that work well.

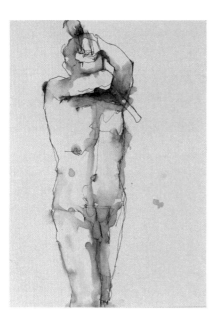 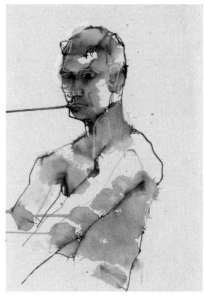

⏱ TWO 3-MINUTE POSES

Both of these drawings came from 3-minute exercises during a life drawing class. Afterwards the artist added coffee to bleed the lines and create areas of tone.

DEVELOPING YOUR OWN STYLE

Once you have got the hang of the basic drawing process it is important to keep searching for new elements and ways of working that you can add to your drawing mix, as these will help you to develop a 'style'. When you're setting out it is fine to copy the style of people you like (we all need a reference or a starting point), but as you develop you should be looking to move in your own direction.

GET INSPIRED

Going to drawing exhibitions and looking at drawings from other people will open up a dialogue in your mind that can suggest and inspire new ideas. Being a part of a drawing group can also help, since it will mean you are surrounded by artists who are working in different ways, some of which may inspire your own work.

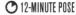 **12-MINUTE POSE**
This drawing was made using willow charcoal, putty, compressed charcoal and coloured chalk.

AFTERCARE

Drawing is like going to a gym: you are training yourself and getting 'fit' in the fields of observation and drawing. While it's okay for you to turn off your mind when drawing (or training), there is a very important time when the brain is needed and this is after a drawing session, when you review your work. You shouldn't be trying to psychoanalyze your drawings at this stage, but you do need to look at them consciously and objectively, so you think about where and how you can develop and improve.

REVIEWING YOUR DRAWING

This process is important, as it provides a structure that enables you to grow with your drawings. It is fine just to keep drawing, but if you don't stop and look at what you have achieved – and consider where you could go next – you can become lost and frustrated. When you don't see a progressive development it might even make you give up completely!

STEP-BY-STEP
The following step-by-step process suggests how you might deal with (and care for) your drawings after you have completed them.

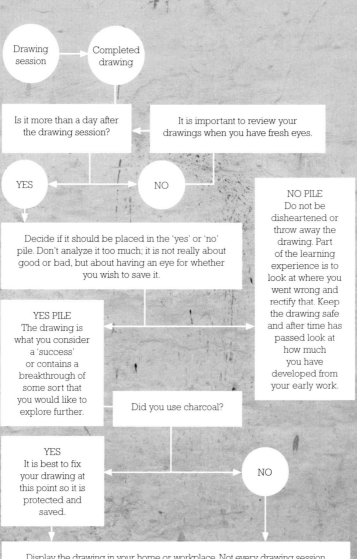

Drawing session → Completed drawing

Is it more than a day after the drawing session?

It is important to review your drawings when you have fresh eyes.

YES

NO

NO PILE
Do not be disheartened or throw away the drawing. Part of the learning experience is to look at where you went wrong and rectify that. Keep the drawing safe and after time has passed look at how much you have developed from your early work.

Decide if it should be placed in the 'yes' or 'no' pile. Don't analyze it too much; it is not really about good or bad, but about having an eye for whether you wish to save it.

YES PILE
The drawing is what you consider a 'success' or contains a breakthrough of some sort that you would like to explore further.

Did you use charcoal?

YES
It is best to fix your drawing at this point so it is protected and saved.

NO

Display the drawing in your home or workplace. Not every drawing session will deliver good drawings. You should aim to have three drawings on your wall at all times. Each time a new good drawing is made you can replace one of the older drawings.

The drawings that don't make it on the wall should be kept in a dated folder, along with drawings that you displayed on the wall and have since replaced.

FRAMING

A successful drawing that stands out as a finished piece of work is the payback for all your hard work and is what will fuel your desire to continue developing. When one of these drawings comes to you, celebrate by having it framed. This will not only protect the drawing, but there is something about having a picture behind glass that helps give distance and will really allow you to look objectively at your work.

SHOWCASE

Framed drawings always make a nice gift for a friend, but you might also consider entering them into group exhibitions or competitions in your area. These types of event are the ideal opportunity for an artist to show their work and receive feedback from a wider audience, rather than simply family and friends.

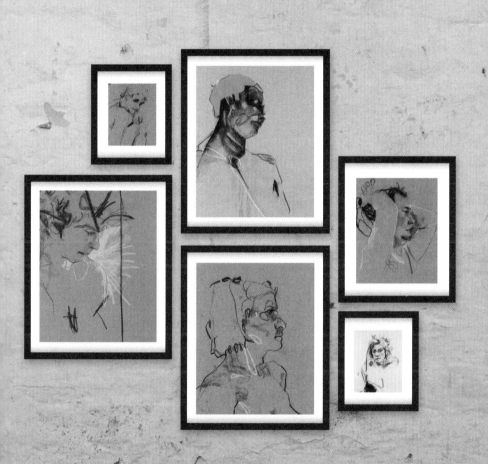

WORKING IN SERIES

A lot of artists work in 'series', making a body of work that explores a single subject or idea over a period of time. An artist might spend a summer working only on portraits, for example. At the end of this period, the artist will go through all of the portraits and select the successful ones.

RESTRICT YOURSELF

You might want to introduce certain restrictions and 'rules' for a self-made series. For example, perhaps all the portraits need to be drawn on the same type of paper, using the same materials? The huge benefit of giving yourself this kind of restriction is that you are forced to explore the materials in full, because you are confined to them.

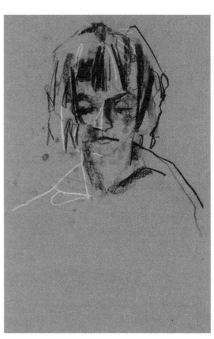

PORTRAIT SERIES

The powerful thing about a series of drawings is that it starts to communicate something bigger then the individual sketches. Look at this group of portraits and think of the reasons why they could be created in a series.

TIME LIMIT

Alternatively, the restriction could be more conceptual. For example, perhaps each portrait is given the same time limit, or you make only portraits of a particular type of person, such as a dancer or someone from a particular generation. Each portrait will explore the individual, but the series as a whole will bring something new to the mix.

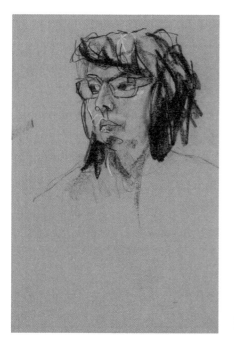

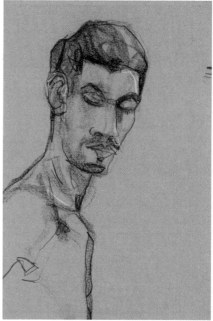

PORTRAIT PROJECT

A self-directed project is a great way to introduce structure and focus to your development. It can also be a fantastic and rare opportunity to spend a concentrated period of time with a model or friend.

① PLAN

Set yourself a goal in terms of the number of portraits you would like to make. It is also useful to set a time structure that fits with your life. For example, you might decide to make 10 portraits, every Saturday, for 10 weeks, resulting in 100 drawings.

② TIME

Allow no more than 3 hours for drawing. You can always make the sessions shorter, but 3 hours is about as long as a single drawing session should be. A good way to plan your day is to draw for 30 minutes and then take a short break to give the model and yourself a chance to rest.

③ MODEL

Pick your models carefully. It is good to draw friends and family; people that you know you'll enjoy spending time with and who will be happy to sit for a long period.

④ POSE

Discuss or let the model choose the pose. To start with you might want to keep it simple with a seated, clothed pose.

⑤ MEDIUM

Consider the materials and the paper you would like to use. Choose a few basic materials that you stick with for your earlier drawings; you can always introduce new materials as your drawing sessions develop.

⑥ STARTING OUT

To begin with, keep your approach direct and fast. If you are using charcoal then use willow charcoal to map out early compositions. As time goes by, bring in compressed charcoal to build up certain areas and focal points.

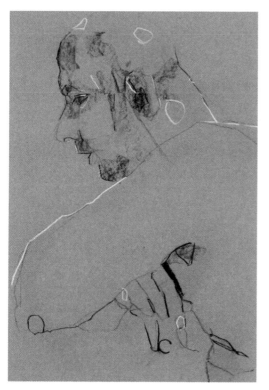

AFTERWARDS

After each session, look at the different qualities and problems within your drawings; with each new session you should be looking to resolve earlier issues. Not all the drawings are likely to be a success, but that's the way it should be – making life-like portraits is not an easy skill to master.

PORTRAIT OF A RELATIONSHIP

If you consistently make portraits of the people you hold close, you will begin to create a beautiful and poetic record of their life. You will also start to see your own life chronologically, through the people who you are close to. Just like a photograph, a person's face can take you back to a certain time and mood. However, when this is executed through a drawn portrait you experience that memory in a much deeper way: you remake the journey of the drawing.

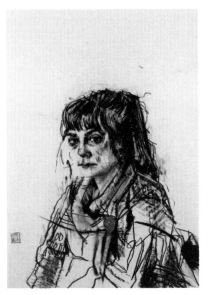

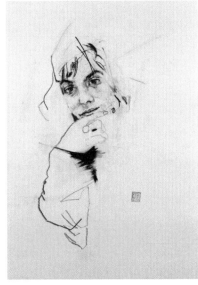

- The likeness does not need to be accurate. Observe fully and transmit what you feel to the paper.
- Do not feel restricted to capturing someone else; you can also draw self-portraits.
- As the series evolves and these drawings are viewed together, the artist will be able to see their mood when the drawing was made, as well as the mood of their subject.

MOMENTS IN TIME

These four portraits – made over a five-year period – are of the artist's partner. In each one we can see a different mood, caught in time.

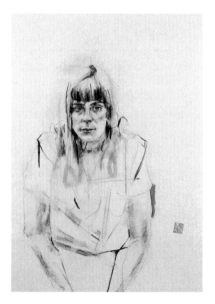

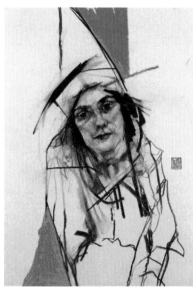

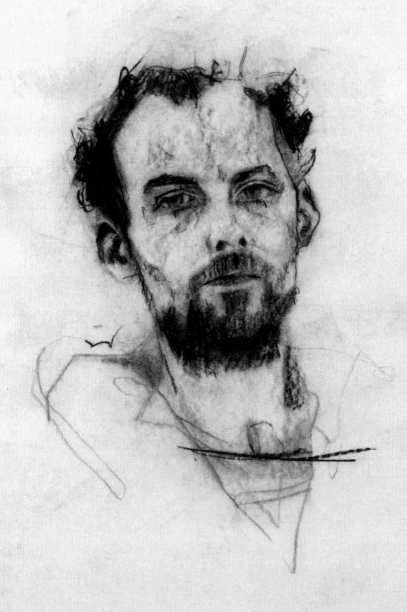

SELF-PORTRAITS

Making a self-portrait is a perfect way to practise without the pressure of having a model pose for you. It can be an intense and reflective experience, which forces you to look at yourself in an honest way and see who you really are.

SETTING UP
It is recommended that your self-portraits are taken from life rather than from a photograph. Take the time to have a comfortable set up that you can return to if you want to do more then one sitting or drawing session. Ensure that the lighting can be replicated, if needed.Work in layers, starting with a rough sketch to find yourself in the drawing and then focusing on the details as the layers develop.

TRIAL AND ERROR
Remember that making a successful self-portrait will take a bit of trial and error. Keep at it, though, as it is the perfect exercise to watch yourself develop. The benefit of this process is that the only person to criticize you is yourself.

A MOMENT IN TIME
In these self-portraits you will find that you catch a time in your life. Taking the time to really examine yourself and your position, at a point in time, can be powerful to look at years later.

⏱ 2-HOUR SELF-PORTRAIT
Here is a self-portrait of the artist in charcoal on paper. This drawing was made over a 2-hour sitting with breaks, standing at an easel and facing a mirror. Always reflect on the way that you have conveyed yourself. Do not be too critical until you become comfortable with the exercise.

LANDSCAPE DRAWING

Creating landscapes drawn from nature can be a very mindful practice, which encourages you to go out into the natural world and connect with the elements. Embrace and enjoy the weather, light and temperature and let it affect your drawings – this is the magic that comes into your work when making landscapes.

A DIFFERENT APPROACH

Landscape drawing requires a different approach to life drawing. With a landscape you need to decide more about what to capture and include, as well as how you will deal with any movement. The sky can be changing constantly, for example, and this can influence the light. Yet whether the light is changing slowly or quickly, don't let it frustrate you – just go with the flow and see where it leads you.

PERSONAL CONNECTION

To start with, find places that you feel connected to and spend time recording and documenting these locations in your drawings. When you look at them together, see if they make you feel the same as you did when you observed them – you might find something in them that isn't possible to put into words, but that communicates with you visually.

VISUAL DIARY

Over time these landscape studies will form a kind of 'self-portrait' that is similar to a visual diary. However, unlike looking at a photograph, you will find that your connection to the place and memory will be stronger when you look back at your drawings.

IRISH LANDSCAPE

Here are two drawings made close to the artist's studio in Ireland. They capture the different elements of nature and the landscape using just ink on paper.

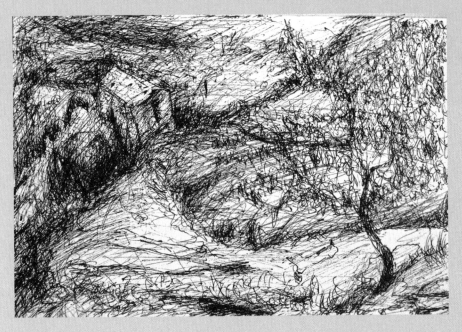

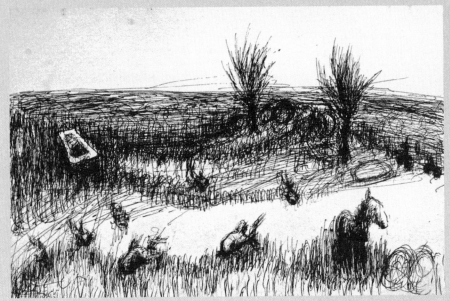

URBAN ENVIRONMENT

Cityscapes contrast with the peace of nature, but they are an exciting and testing challenge. With all the busy life and traffic around you, recording a city scene is a good way to test your focus and concentration. There is a lot of movement in cities, which can encourage you to explore a variety of ways to convey motion in your drawings.

OBSERVING PEOPLE

If you're on a train, at a café or in a similarly busy location, a good exercise is to try and draw the people around you. Part of the challenge is to be in control and not anxious, especially if you are drawing a 'random' person when no consent has been given. In this situation it is up to you to be sensitive and discreet and not to intimidate the person you are drawing or make them feel uncomfortable.

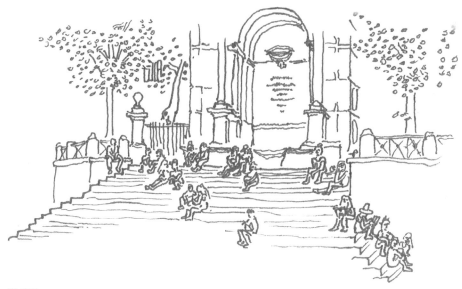

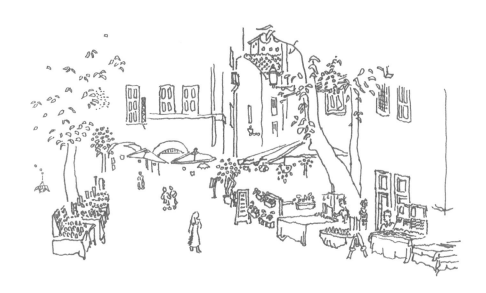

KEEP IT SIMPLE

The approach to making drawings in urban areas is very similar to making landscapes in the natural world. You should keep your materials simple and work on a small scale if you want to keep the experience manageable; a small notebook is the ideal canvas. The important thing is that you take your time to observe and immerse yourself in the scene. The experience of the city will return to you through the lines in your drawing.

ITALIAN CITYSCAPE
You can draw a lot of inspiration from taking the time to study your own town or city. It can give you a different understanding and feeling for a place that may be close to you. It is also fascinating to explore a city that you've visited as a tourist. Here are two pen drawings from a holiday in Italy.

TURNING A HOBBY INTO A BUSINESS

Drawing is the foundation for a lot of artistic pursuits. Those involved in the fine arts, fashion or design use drawing as a way to inform their practice. Having a good understanding of drawing will set you on the right path to develop your abilities as an artist further. Rather than setting out to achieve a career or create a business as an artist, enjoy your drawing and you might see your hobby progress into something more valuable and rewarding.

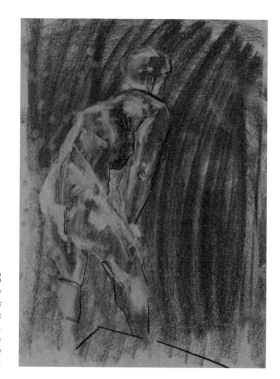

FROM PAPER TO CANVAS
Here is an example of how a painter uses their life drawings within their paintings. You can see the transition from drawing to finished painting.

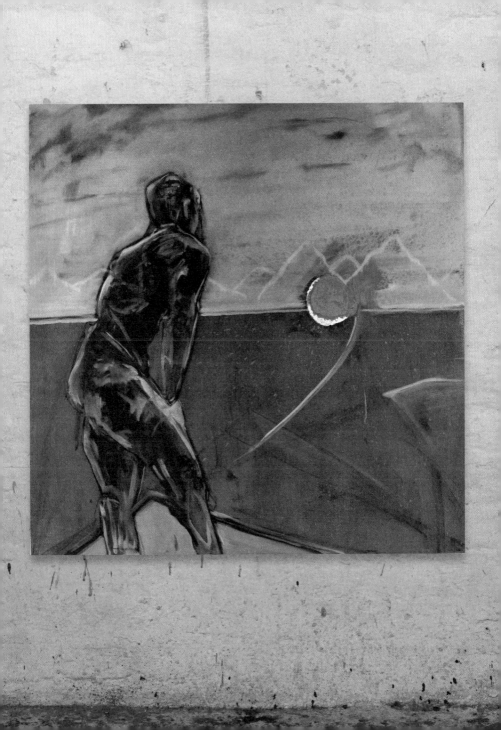

SETTING UP A LIFE DRAWING CLASS

You don't need to be a master artist to run a successful life drawing class, but running a consistent class will make you a master sooner than you think. There are many new and interesting elements when running a class; you must take care of your models, keep a check on timings and encourage the people coming to draw. If you get the balance right it can be a rewarding and intimate experience that brings people together through drawing, and you will see both your drawing and social skills blossom.

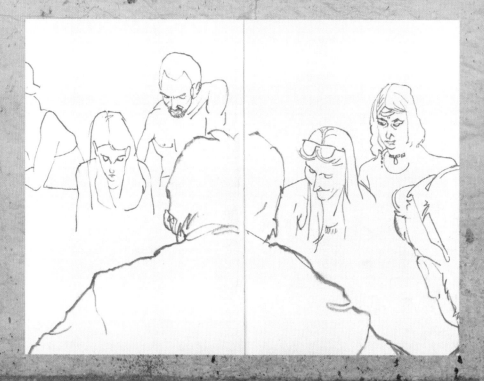

THINGS TO CONSIDER

① SPACE

If you don't have a space where you live or work, then you could rent a private space for an evening or at the weekend. Co-working spaces are often open to the idea of having classes. You could also ask a local library or community centre if they are interested in holding a class. There are no strict requirements; just find somewhere that feels right and suits your needs.

② SUPPORTS

Most people will bring their own paper and drawing materials with them, but there are some things that you may need to supply. The most important thing is to ensure that you have enough boards or easels for everyone to use.

③ STRUCTURE

A tightly structured class will mean you can focus on drawing. However, most life drawing classes are without instruction – they are 'drop-in sessions' where people get straight into it, just like a gym.

④ MODELS

It is important to build up a selection of reliable models that won't let you down, because without a model there is no class. Take your time when you're looking for models, and once they have agreed to work with you be sure to pay them well and keep them warm in the cold months – it is not easy work!

MODEL TIPS

You should try and mix up the models you use, by choosing people of different genders, ages, sizes and shapes. A selection of good models will bring different dynamics to the class. For the class, create a small platform or stage to raise the model a little from the ground; the drawers should be able to surround the model in a circle so they can choose the angle they draw.

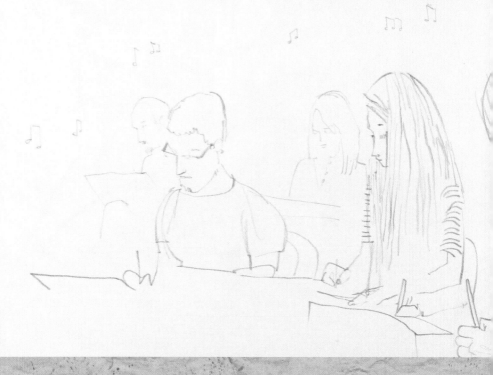

⑤ WARMING UP

During the first half of the drawing session you could include some of the exercises mentioned in the PLAY chapter. Warm up with these exercises and follow them with longer periods of just drawing.

⑥ DRAWING

The poses and timings should be down to the model, and experienced models will know this. It is best to start with shorter poses that are more difficult or include action-type shapes; longer poses need to be more relaxed and comfortable for the model and should be organized towards the end of a session.

⑦ ATMOSPHERE

The best kind of atmosphere is one in which the participants don't talk. This allows people to immerse themselves fully in the drawing experience, without external distractions.

⑧ MUSIC

Music can add a great deal of atmosphere to your drawing sessions. A good idea is to have energetic music for the first hour, and perhaps have the lights running bright. For the second half of the class you might choose to turn down the lights for longer poses, adding more tone of light on the model and creating a mood. The music for this part could be slower, atmospheric and dreamier to reflect the tone toward the end of a class.

RELAX

Finally, provide a pot of tea and good vibes to welcome your students. Remember, you won't be making lots of money from this type of business, but it is a perfect way to keep your own drawing practice going and take your hobby to the next level!

PLAN FOR A CLASS

The following plan shows one way of structuring a 2-hour-long life drawing class. This is a good duration as it gives people time to focus on their drawing, without the sessions feeling overly long. If classes are longer there is the risk that people will lose focus and the model may become tired or distracted.

2-HOUR SESSION

The plan for the session is split into two 'blocks', with a break in the middle. The first hour consists of warm-up exercises and a few poses, while the second hour is concentrated on model poses. It is important to allow time at the end for people to look at each other's drawings and open a discussion about what came out of the session.

0–5 minutes: Five 1-minute drawings (*see page 62*)
5–8 minutes: 3-minute continuous line drawing (*see page 64*)
8–11 minutes: 3-minute contour line drawing (*see page 66*)
11–14 minutes: 3-minute tonal drawing (*see page 68*)
14–17 minutes: 3-minute non-dominant hand drawing (*see page 70*)
17–20 minutes: 3-minute blind drawing (*see page 72*)
20–27 minutes: 7-minute pose
27–35 minutes: 8-minute pose
35–45 minutes: 10-minute pose
45–60 minutes: 15-minute pose
BREAK
60–70 minutes: 10-minute pose
70–80 minutes: 10-minute pose
80–95 minutes: 15-minute pose
95–120 minutes: 25-minute pose
DISCUSSION

THE NAKED MODEL

The main reason that life drawing models are naked is so that you can see all the details of the human form. Having the model unclothed brings an intimacy to the drawing, enabling you to explore visually the figure's beauty and shape. If you are holding a life drawing class and using naked models, the main thing is that you make both the model and those drawing feel relaxed: no one should in any way feel uncomfortable.

THE CLOTHED MODEL

Not all life drawing classes require a naked model, though. You could have some of your classes with clothed models, such as portrait sessions or a costume session. Clothing simplifies the pose, which can make it easier to deal with the whole figure in a drawing.

⏱ 6-MINUTE POSE

In this sketch the artist uses willow charcoal as a base layer and the putty rubber to pull the contours of the body from the page. Compressed charcoal is then used to place darker lines, adding depth. The final layer of white chalk emphasizes the light hitting the model.

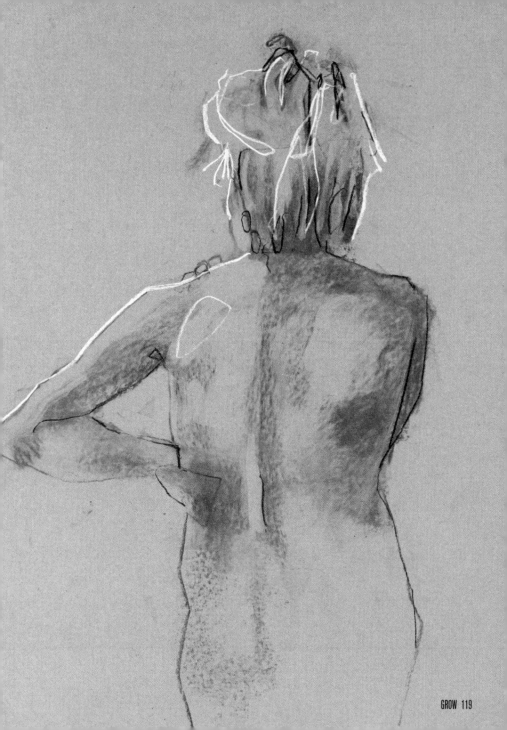

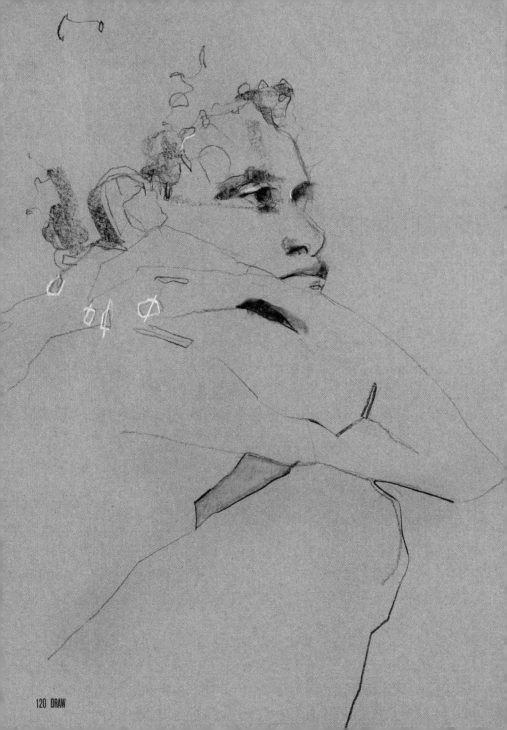

MINDFULNESS IN DRAWING

In today's busy world there is a lot of focus on attaining mindfulness. There are many different meditations and spiritual practices available and people are desperate to find something that works for them. The truth is that in drawing you have the perfect structure for attaining this peaceful headspace.

THINK LIKE A CHILD

The first step is to accept that as soon as you were born and your motor skills were developed, you had the ability to draw. The first time you were asked to draw your parents, a pet or the seaside, you didn't question your ability: you just went for it! If you can re-awaken this confidence in yourself, the door to mindfulness will be wide open, waiting for you to walk through.

HAVE FUN

Focus and have fun with the process when you are drawing, rather than worrying about the result. After just a few drawing sessions you will notice your mind becomes a lot calmer. The reason why mindfulness can be attained easily through drawing is because it is not your direct mission. Mindfulness is about being able to focus on the present moment and drawing will naturally bring you to this place without you having to search for it.

THE BENEFITS OF DRAWING

As a result of this, drawing can help you deal with all manner of things, including anxiety issues and depression. The practice of art as a form of therapy is becoming more and more popular, and the success of colouring books for adults is a clear example of this. You will notice that after a 2-hour life drawing class you have the best kind of sleep: it is the perfect way to resolve issues in your life, gain clarity and calm your mind.

THE STUDENTS' VIEW

Here are some profiles of people who attend life drawing classes, with an image of one of their drawings and answers to two questions: what brought them to a life drawing class? And what do they get out of a life drawing class?

EMMA TRIPOLONE

'I was always drawing as a child and continued this through high school. I think it was my art teacher at school who suggested I go to a life drawing class. I enrolled in a class after school and went. From then on I loved it. The class had a range of students, young, old, novice and experienced. I learnt a lot there and my experience formed a strong basis for me to draw the human form.

I find a life drawing class to be very relaxing. The drawing makes you focus on one task while letting your mind relax. I always find that the more relaxed I am the better I draw. Also, when I am not focused on making the drawing look like anything in particular and view the body as a series of shapes and lines, I create more interesting drawings.'

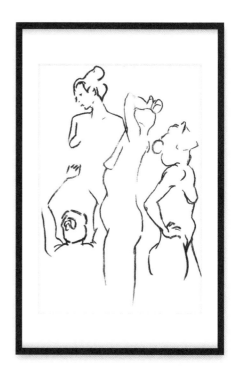

ANN-SOPHIE

'To me the most interesting thing about life drawing, as for a lot of other people I suppose, is that it sharpens your observation skills. That might sound pretty mundane but it proves quite hard to follow your direct impression rather than your preformed idea of something – in the case of life drawing the reality of the human body. Since I tend to overdo things I also like the limitation of time, which forces one to abstract certain features to create a strong picture. In a way this conflicts with the former principle but builds upon the ability to observe closely a complex system and break it down into essential shapes.

Two hours of trying to be or being present has led to quite a lot of awful pictures and a handful of good ones.'

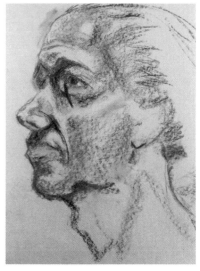

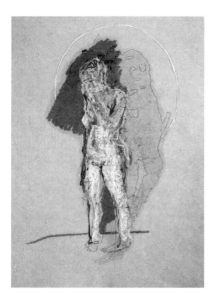

CHARLOTTE REIBELL

'It´s the idea of being part of a group that made me interested in going to a life drawing class more than the desire to learn how to draw. I like drawing people but I find it much more intimidating when I´m alone in front of the model; the class and the people around help to create a relaxed atmosphere to work in and focus on what we see. Drawing in a room with 10 other people and a model, the sound of the charcoal, pencils, brushes dipped into water and the intense concentration takes you away from self-consciousness and brings you to a meditative space. It takes the fear of not achieving a good drawing away and helps you to treat drawing as a practice; that´s what we all do here on a Monday night, like in a gym class. And it works, as soon as you take the fear away and start playing around you also make good drawings!'

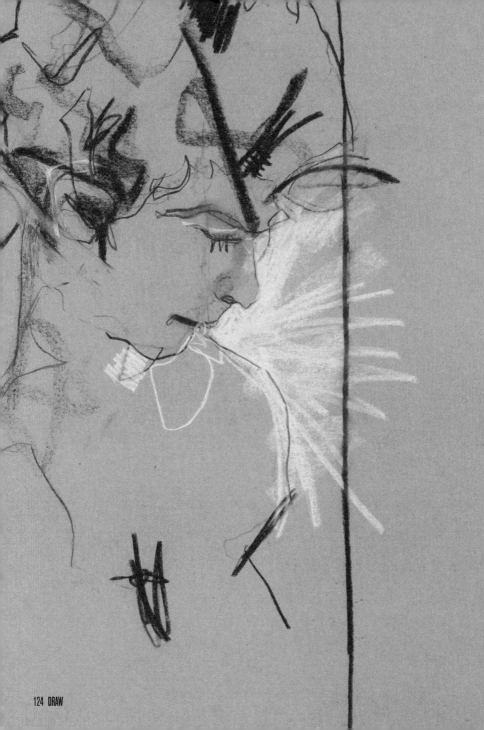

RESOURCES

BOOKS

Berger on Drawing
John Berger
Occasional Press, 2007

WEB SITES

Drawn To That Moment
An essay by John Berger
www.spokesmanbooks.com/
Spokesman/PDF/90Berger.pdf

An Taobh Tuathail – The Other Side
An Irish digital radio station
www.rte.ie/rnag/an-taobh-tuathail

David Hedderman
www.davidhedderman.com

FILMS & DOCUMENTARIES

Alice Neel
A documentary by Andrew Neel
SeeThink Films, 2007
www.aliceneelfilm.com

*Alberto Giacometti - What Is A
Head / A Man Among Men*
Two documentaries by Ernst
Scheidegger & Peter Munger
Quantum Leap, 2001

*Jean-Michel Basquiat : The
Radiant Child*
A documentary by Tamra Davis
Arthouse Films, 2010

John Berger: The Art of Looking
A documentary by Cordelia Dvorák
BBC Films, 2016

INDEX

A
acid-free paper 16
Ann-Sophie 123

B
benefits of drawing 121
blind double portraits
 74–5
blind drawing 72–3
business, drawing as a
 110

C
chalk, white 26–7
 on dark paper 76–7
chalk pastels 29
chamois 31
charcoal
 compressed 20–1
 willow 18–19
charcoal paper 16
cityscapes 108–9
classes
 finding 12–13
 plan for 116
 setting up 112–15
colour 28–9
composition 55
compressed charcoal
 20–1

continuous line drawing
 63–5
contour line drawing 66–7
contrast 48
cropping 59

D
design, elements of 54
 composition 55
 focal points 58–9
 perspective 56
 proportion 56
drawing boards 32
drawing boxes 31
drawing clips 31
drawing folders 31
drawing tubes 31

E
easels 32
erasers 22–3
experiments 88
 different paper 90
 ink and coffee
 drawing 91
 twig and ink drawing 89

F
five one minute poses
 62–3

fixative 30
focal points 58–9
four-step combined
 drawing 78–9
framing 96
friends and family 41

G
gallery visits 87
Giacometti, Alberto 6
graphite paper 16
graphite pencils 24–5

H
head, drawing the 52–3

I
ink and coffee drawing 91
inspiration 92

L
landscape drawing 106–7
layers, drawing with 50–1
less is more 59
life drawing 36
 as finished work 39
light 34
line 44
 techniques 47
location, working on 86–7

M
masking tape 31
mindfulness 121
models 13, 36, 113, 118
 friends as 41
movement, 82
music 34, 115

N
negative space 67
non-dominant hand
 drawing 70–1

O
observing people 108
oil pastels 29

P
paper
 experiments 90
 types 16–17
pastel paper 16
pastels 29
pencils 24–5
people, observing 108
perspective 56
plan for classes 116
plastic erasers 22
portfolios 31
portraits 40–1

as series 98–103
 see also self-portraits
proportion 56
putty rubbers 22

R
Reibell, Charlotte 123
relationship, portrait of a
 102–3
reviewing drawings 94–5
rubber erasers 22

S
score drawing 83
self-portraits 41, 105
 the head 52–3
series, working in 98–103
sketchbooks 86
sketching paper 16
standing-to-lying pose
 84–5
stumps 30
style, developing 92
supports 32

T
timing drawings 34
tonal drawing 68–9
tone 45, 48–9

Tripolone, Emma 122
twig and ink drawing 89
U
urban environments
 108–9

V
vinyl erasers 22

W
water 30
watercolour 29
watercolour paper 16
weights of paper 16
white chalk 26–7
 on dark paper 76–7
willow charcoal 18–19

ACKNOWLEDGMENTS

A special thanks to my mother Rose, and my sisters Zara, Annick, Emma and Jen. Thank you to Charlotte Reibell, Paul McDermott, Conor and Pete, Francois, Harm, Michael and Matthias @Atelier ¾. To Aodhan Rike for giving me a pencil, and to all the people who have supported me as an artist. I am grateful to those who have come to my classes and the models who have shared so much with us!

To the contributors of this book:
Charlotte Reibell
Kevin Ryan
Emma Tripolone
Ann Sophie Stueckle
Bradley Gillis
Daniel Lipstein
Leonardo González
Katelyn Stiles

A massive thanks to Matthias Von Wallbrunn for help with photographing my drawings.

To Jamie and Robin for their support and collaboration.

Love and light to you all!
David
www.davidhedderman.com

AMMONITE
PRESS

www.ammonitepress.com